Arousing Sensation

Edited by Sylvie Gilbert

A Case Study of Controversy Surrounding Art and the Erotic

BANFF CENTRE PRESS

D0916764

The Walter Phillips Gallery gratefully acknowledges the financial assistance of the Canada
Council for the Arts' Exhibition Assistance Program.

The Canada Council | Le Conseil des Arts
FOR THE ARTS | DU CANADA
SINCE 1917 | DEPUIS 1957

CANADIAN CATALOGUING IN PUBLICATION DATA

 Main entry under title:
 Arousing sensation
 (WPG Editions)
 Includes index.
 Based on the exhibition, Much sense: erotics and life, at the Walter Phillips Gallery.
 ISBN 0-920159-82-6

 1. Erotic art. 2. Sex in art. 3. Erotic art – Alberta – Exhibitions.
I. Gilbert, Sylvie. II. Walter Phillips Gallery. III. Series
N8217.E6A76 1997 704.9'428 C95-910879-3

Book Design: Alan Brownoff
Printed and bound in Canada by Hignell Book Printing Ltd., Winnipeg, Manitoba.
Images scanned by Screaming Color Inc., Edmonton, Alberta.

BANFF CENTRE PRESS
The Banff Centre for the Arts
Box 1020 – 17
Banff, Alberta
Canada T0L 0C0
TEL (403) 762-7532
FAX (403) 762-6699
WEBSITE http//www.banffcentre.ab.ca/writing/press

THE BANFF CENTRE
FOR THE ARTS

Dedicated to Robert Flack
14 October 1957 – 20 October 1993

Sex, and its many guises, Foreword

has the distinct ability to arouse a response in most of us. Its representations are increasingly prevalent in newspapers, magazines, on television and the Internet. Its images irk, fascinate, repulse, seduce and intimidate. The basis of this book is an exhibition titled *Much Sense: Erotics and Life*, in which Sylvie Gilbert undertook a curatorial investigation of eroticism, and worked with a select number of artists who engage with issues of sexuality. After all, if art is spawned by its social context, why not look at one of society's fascinations from an artistic perspective?

When *Much Sense* was presented at the Walter Phillips Gallery, the response to it revealed many of the strong views that exist around sexuality and eroticism. Public reaction was intense but divided: on one hand, there was gratitude that viewpoints on lesbian love, the anorexic body and the spirituality of the sexual act had an opportunity to be voiced. On the other, many responses extolling traditional values were also heard. In the debate that spread far beyond the gallery, fundamental questions arose. Why does it seem permissible to see sexually charged images on television and in newspaper ads but not in art galleries? Why are images of heterosexual love acceptable, while those of homosexual love are not? Why are images of the nude male body still apparently taboo? This case study explores some of these questions while situating the public art gallery in the midst of such debates.

The philosophical considerations around such events are engaging, and when audiences, politicians and the media complain, the discussion gets hot. Subtle and not-so-subtle pressures begin to appear on the gallery and its staff—self-censorship and fear can take root. It takes strength to face up to the response and maintain an active role in helping to facilitate the very same debates that are carried out in communities at large.

DAINA AUGAITIS, *Former Director*
Walter Phillips Gallery
Fall 1994

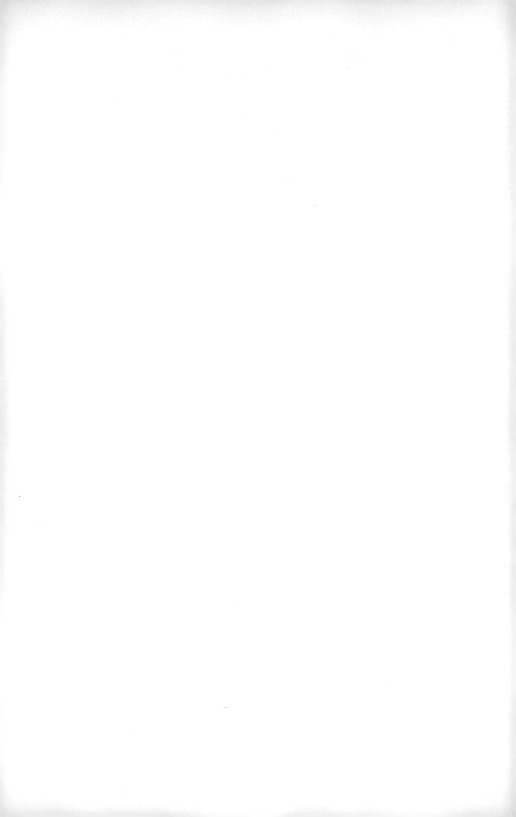

Acknowledgements

It is important to acknowledge the courage behind Sylvie Gilbert's curatorial vision and the determination underlying the artists' work—the sculptures of Maureen Connor; the installations and performances of Kiss & Tell (Persimmon Blackbridge, Lizard Jones, Susan Stewart); the photographs of Robert Flack; the films and videos of Peggy Ahwesh and Keith Sanborn, Sadie Benning, Lorna Boschman, Colin Campbell, Stasie Friedrich, Leslie Asako Gladsjo, Paula Levine, Midi Onodera, Pratibha Parmar, Greta Snider, Lisa Steele, Katie Thomas; and the analysis and poetry of Su Ditta, Thomas Allen Harris, Myrna Kostash and Thomas Waugh. We thank all of you for the richness and clarity of your perspectives. We are grateful for loans made by the Germans van Eck Gallery, Canadian Filmmakers Distribution Centre, Drift Distribution, V Tape, Video Data Bank, Women Make Movies and to all the artists for the opportunity to share their artworks with our audiences. We thank the Canada Council for the Arts' Exhibition Assistance Program for financial assistance towards the exhibition and publication, as well as unwavering moral support.

The project came to fruition with the commitment and hard work of gallery and visual arts staff, who provided the framework for the exhibition: Deborah Cameron, gallery coordinator, handled innumerable organizational details; Sally Garen, gallery assistant, as well as Robert Knowlden, sculpture facilitator, contributed to the installation; Marilyn Love, curatorial assistant, provided curatorial support; Mimmo Maiolo, preparator, oversaw the inspired installation; Pauline Martin, assistant manager, tracked the overall finances; Mary Anne Moser, publications editor, designed the printed materials; Wendy Robinson, administrative assistant, contributed to important details; and Mary Squario, publications assistant,

provided design and production coordination. Technical support for the performance was organized by Kerry Stauffer in Technical Services, while Tim Westbury provided installation assistance. Jon Bjorgum and the staff in Communications capably handled media requests, and constructive encouragement was offered by Carol Phillips and Sara Diamond.

This important book has been thoughtfully conceived by Sylvie Gilbert, with the hope that it may be valuable to others involved in the study of art and sexuality. Mary Anne Moser's enthusiasm and creativity were felt in the initial coordination and editing. She worked closely with Mary Squario, who handled design and production in those early stages. Alan Brownoff provided the final design and was responsible for production of the book. Penny Lawless provided valuable assistance with typesetting portions of the manuscript. Additional typesetting was provided by Erin Michie. The photographs of the exhibition and performance were taken by Don Lee and Cheryl Bellows, the Banff Centre's photographers, and Doug Smith assisted in obtaining stills from the videotapes. We are also grateful to Catherine Crowston, who managed the project through its initial stages, and to Lori Burwash and Lauri Seidlitz, who saw it through to completion. Thanks are also extended to the many writers, magazines and newspapers who gave their permission to reprint articles that form the media debate section.

To all who have contributed to the ongoing debates about sexuality through support of this exhibition, performance and book, thank you.

DAINA AUGAITIS, *Former Director*
Walter Phillips Gallery
Fall 1998

Erotic. Life.

Erotic. Life. Though these are common words, who today can avoid the debates about meaning surrounding these two terms? To subtitle an exhibition *Erotics and Life* is to set up a context in which discussion about definitions clearly must take place. Such discussion proceeds from simple but unavoidable questions: What aspects of life are erotic, erotic in what way, and for the pleasure of whom? The exhibition *Much Sense: Erotics and Life* presented artworks that opened dialogue on erotics and sexuality by posing such questions. Rather than functioning as erotica themselves, the artworks contested the usual associations with the erotic in everyday life.

Much Sense
EROTICS AND LIFE
Sylvie Gilbert

When the idea for this exhibition came about, a great deal of activity in visual art, popular music, publishing and broadcasting was related to the exploration of sexual experience. The word sex was out—every week one could expect to see a special article in a magazine or a new music release about sex. The public was curious and opinions were flowing.

Sex sells. No one can dispute this axiom of our consumer society. While it sells, it also irritates, and for the most part it irritates when publicly discussed or presented. It seems that the degree of irritation depends upon the viewer's expectations about the place for the erotic in everyday life. In the context of a society that is fascinated by—and apprehensive about—sexual content, the artists in this exhibition use photography, video art, live performance and installation to understand the power of sexual desire and its relation to our everyday lives.

Like high heels, feminine lingerie in western societies is immediately symbolic of sexual appeal, excitement, titillation—and part of the conventional repertoire of erotic articles. New York artist Maureen Connor uses pieces of lingerie precisely for that reason. As erotic items, they are the garments that mark the transition between

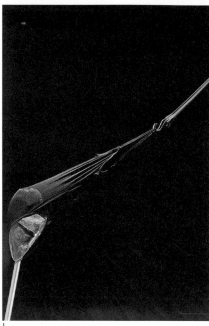

| MAUREEN CONNOR, *Untitled* (1989) detail

being dressed and naked, and they are in contact with the genitals. For these and other reasons, lingerie is often fetishized. While it highlights the body, hides the genitalia and signals vulnerability, most of the time it can be seen through.

The images Connor creates with conventional lingerie, however, are unsettling. The black body suits in her sculptures are twisted, stretched and elongated with thick black rubber straps on metal armatures. The flesh of the body has disappeared, leaving only skeletal material where the pulsating body would be, a taut rack the only witness of the disappeared. The erotic in Connor's work is invested in the garment and the posture; a trauma is evident in both. In *Untitled* (1989), the body has disappeared, leaving in its place only a large wax stomach. Could the body have been digested by gastric juices of a starved organ?

Connor's work addresses a very disturbing phenomenon related to the obsessive association of the erotic with the perfect body. The works call to mind the distorted relationships between body image, self-perception, social expectation, pressure to conform and narrow definitions of beauty. Holding the chimera, they suggest the collective neurotic fixation on the ideal body. The association of the erotic with beauty is so perverse as to affect one's sense of self to a point that reality and perception become disjointed.

The artist creates an evocative installation for several sculptures that focus on this theme. On the walls enclosing the works, a series of light fixtures cast an intimate golden glow that contrasts with the

| **MAUREEN CONNOR** (1990) installation view

usual bright illumination from the gallery ceiling. This specific
arrangement reminds viewers of the atmosphere of high-fashion
boutiques, where a limited selection of articles is intended to create
a sense of exclusivity in consumers' minds. In flirting with the aes-
thetic of the boutique, Connor alludes to a confusion that emerges
when clothing is seen to embody the self, when the fashion item
becomes more desirable on display than on a body. Representing a
misguided attempt to find an outlet for desire, this series equates
the boutique with fashion, glamour with sex appeal and, ultimately,
clothing with sex and shopping with desire. Such associations have
a great impact on body image. In this atmosphere, the body must
conform to become an object of desire, slowly disappearing,
starving, to reveal the armatures, the shoulder bones, a membrane
dangling from hangers.

Today medical and gender research suggest that anorexia is a
syndrome occurring primarily in the female population and usually
in the period of one's life when the body has matured and female

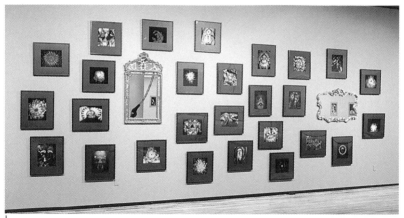

| ROBERT FLACK, *Love Mind* (1992) installation view

identification is inevitable. Recent research suggests that anorexia is related to difficulties with sexual identity. More directly, it suggests a refusal to appear as an adult and sexual being—by erasing the signs of sexual development of the body by keeping it thin.[1]

Connor departs from the conventional vocabulary of the erotic with this series She alludes to a phenomenon in society of a human being's refusal to become a sexual body with its own desires. Left in place is erotic longing.

On a large mauve wall framed by twelve-foot-high royal blue velvet curtains, Robert Flack sets up his series of colour photographs under gilded cornices. The dimly lit space is elaborated with mirrors, a disco ball, two flowering hibiscus trees and a circular ottoman. The thirty photographs are part of *Love Mind*—shots of a male human body on which graphic symbols and patterns are projected.

The graphics in *Love Mind,* created by Flack, are influenced by Celtic designs, contemporary tattoo images and cartoon symbols, while the work as a whole reflects the artist's study of the Tantric body. For several years prior to creating this work, after being diag-

nosed with HIV, Flack was spiritually inspired by the unifying principles of mind, body and soul of Tantric meditation. By following the Tantra—the mystical and magical writings that inform Hindu and Buddhist love manuals such as the *Kama Sutra*—a prolonged state of ecstasy can be achieved through the demanding steps of meditation. The Tantric body is a temple, seven chakras or points of energy; an ecstatic state can be attained by mastering the flow of energy between chakras. The artist invested in this positive energy to maintain a healthy body and mind.

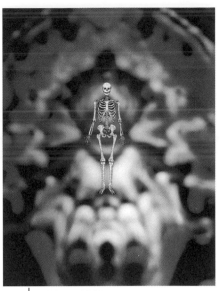

| ROBERT FLACK, *Love Mind* (1992) detail

To adorn the body with patterns, Flack used light projections. The projected motifs hover between the skin and the lens of the camera—immaterial and temporal. Intense, colour-saturated light is beamed onto the body, irrigating its pores like water, enveloping the flesh as a caress.

Amid the photographs, mirrors are installed in baroque gilded frames to reflect the work on the other side of the gallery as well as to capture the reflections of viewers. With this layout the artist has made evident a system of looks and looking that contributes so much to sexual interaction and pleasure. The looked-at and the looking bounce off each other, initiating the return of the gaze: you see yourself looking at images of a naked body.

Public establishments such as the club, the bar and the bistro use mirrors to create environments for subtle voyeuristic interactions. Mirrors transform a space that is public into a private, intimate and sexually charged environment. The experience of riding an elevator or waiting in a reception area shows how the interaction can at

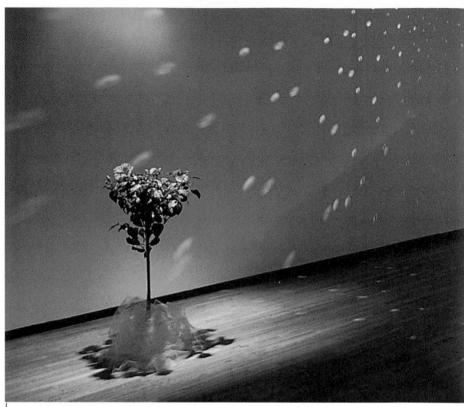

| **ROBERT FLACK**, *Love Mind* (1992) installation view and
Much Sense reading area

times be forced. In the gallery space, the artist has altered the site, fused the atmosphere of the club and boudoir to shape a public space for desire, an interior place for pleasure.

By drawing upon diverse architectural spaces that have been used and romanticized as sexual locations—from the nightclub to the bedroom—Flack activates the theatrics of sexual experience to further concentrate the experience of viewing the photographs. The resulting meditative space contributes to the vibrant sexual energy swirling amid the photographs.

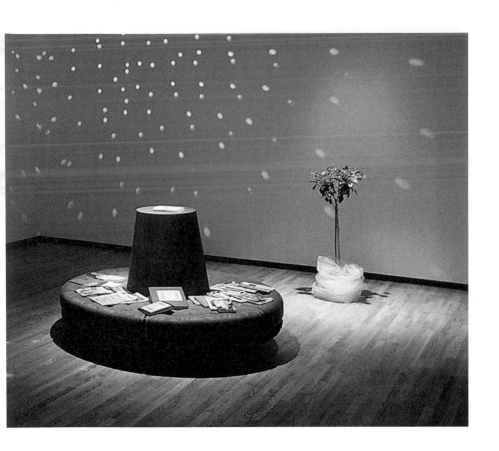

While Flack draws on the boudoir as a site for desire, and Connor uses the boutique, Kiss & Tell refer to the playground for their exploration of sex and everyday life. Susan Stewart, Persimmon Blackbridge and Lizard Jones, who make up Kiss & Tell, explore female sexual desires and practices as members of the lesbian community. The playground—be it a park or an alley—is used in this work as the first social space where kids interact beyond the authority of parents or guardians. Just as games provide an under-

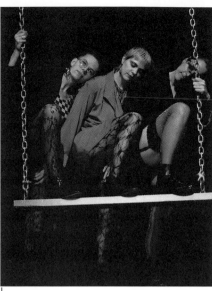

KISS & TELL, *True Inversions* (1992) performance

standing of social interaction, they also provide a testing ground for sexual interaction. Kiss & Tell's work is autobiographical and challenges stereotypes of lesbian sexual representation. For this exhibition, Kiss & Tell presented an installation and performance, both under the title *True Inversions*.

In the gallery space, a larger-than-life swing is at the centre of the installation. It is fastened to the floor in front of a closed-circuit camera and monitor that shows viewers on the swing what they look like to the camera. Photographs on two walls framing the swing show unconventional images of lesbians. On the gallery walls next to the images are handwritten excerpts from the performance, which present different women expressing desire for another female body.

In a well-documented essay, Cyndra MacDowall gives a historical overview of the representation of lesbian sexuality and identity.[2] She points out that from its inception in the nineteenth century, photography was used to produce sexual images. Photographs of lesbian sex have circulated since then as well; however, the vast majority of lesbian sexual images have been produced by and for the pleasure of heterosexual men. Similarly, representation in cinema of two women being sexually active (or potentially active) has enduring popular appeal for this audience. As lesbians, the artists in Kiss & Tell use the images to convey their desires, experiences, imaginations and bodies—the black-and-white photographs do not work as signifiers for a heterosexual gaze. Judging from comments made by visitors to the exhibition, heterosexuals do not find these images erotic. As MacDowell reminds us, there are drifts in representation. For example, "while butch-femme role representa-

tions frequently appear within lesbian-made imagery and documentary images of lesbians, they rarely appear in male-produced material."[3]

The three-part performance explores complex issues surrounding lesbian sexual representation, desire and censorship. The trio share stories of their communities, their relationships with their mothers, men, and with friends. Exploring different facets of their lives, they always present the multiplicity of identity that they, as lesbians, encompass.

In one tableau the artists include stereotypical images of lesbians in mainstream cinema and in the pornographic film industry. The films are projected onto a backdrop while a woman representing a cleaning lady is on stage. Embarrassed by the images, the cleaner uses her rag in an attempt to hide the X-rated representations.[4] To provide context for the soft-porn film clips, a video written, produced and starring Kiss & Tell and directed by Lorna Boschman is screened as part of the performance. Many of the languorous images used in heterosexual representations of lesbians are absent; in their place are images and texts that raise issues of safe sex, friendship and state control of the erotic.

In another tableau each artist reads a letter to her mother. One proudly recounts a relationship of trust and understanding, telling the story of her mother marching for a day in a lesbian pride parade. Another says that she conceals from her mother the fact that she is lesbian, for fear of being rebuffed. Their respective differences highlight the ways that mother-child relationships—for all human beings, regardless of sexuality—is a complex unfolding of imagination, hope and self-representation.

The performance is conceived as a panorama of issues that confront lesbian life. Demonstrating strength and courage, the three artists maintain the paradoxes, political disagreements and lack of resolution inherent in broad questions about sexuality and everyday life as a way of opening up debate for the audience. It is not surprising, then, that Kiss & Tell choose, among other forms such as photographs and book works, performance as a means to activate discussion about situating lesbian representation. Performance offers the advantage of flesh and blood right in the face of viewers.

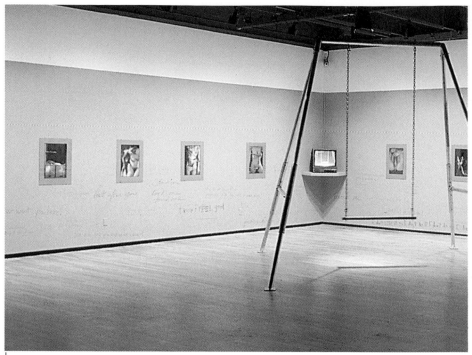

| KISS & TELL, *True Inversions* (1992)
installation view

While the artists may inhabit characters, their heartbeats and sweat prove that lesbians are out and that they are speaking. *True Inversions* revealed for a one-hour period the existence of lesbian life, sexuality, and the representation of this sexuality in an intolerant society.

Together, the works of Maureen Connor, Robert Flack and Kiss & Tell open several points of entry to debate about desire. They examine the politics of sexual pleasure and question patterns that lead to the sanctioning of some sexual acts and the condemnation of others. In a culture fascinated by sex—where sex is exploited, repressed and manipulated, but rarely analyzed—these issues are well worth understanding.

Spring 1995

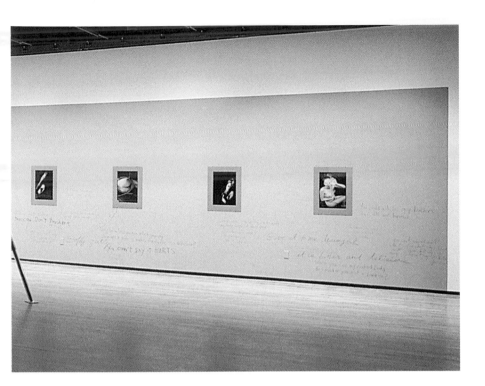

NOTES

1 Louise J. Kaplan, *Female Perversions: The Temptations of Emma Bovary* (New York: Anchor Books, 1991).

2 Cyndra MacDowall, "Sapphic Scenes: Looking Through a History," *Fuse* 14:4 (Spring 1991), 25–39.

3 Ibid., 27.

4 This was the "masturbation scene" that Rick Bell blew out of proportion and was referred to frequently in the media debate.

The five films and eight videotapes in *Much Sense: Erotics and Life*

must have been strong stuff for the ethereal mountain atmosphere of The Banff Centre for the Arts. Watching bodies being pummeled, pressed, prodded, probed, pierced, penetrated and pissed on, as well as prized, petted, proffered and proudly pumped, for almost four hours left even this jaded viewer from down East not only alliterative, but gasping for oxygen.

Women's bodies, lives and sexualities are the substance of this remarkable

My Body is not a Metaphor

THOUGHTS ON FILMS AND VIDEOS IN MUCH SENSE: EROTICS AND LIFE

Thomas Waugh
In memory of Esther Valiquette

show. Leading women artists in film and video are presented alongside the upcoming generation: from Canada, Lisa Steele, Midi Onodera and Lorna Boschman together with Kate Thomas and Stasie Friedrich; from the United States, Peggy Ahwesh and Paula Levine together with Sadie Benning, Greta Snider and Leslie Asako Gladsjo; from the United Kingdom, Pratibha Parmar. Also included are Toronto video artist Colin Campbell and Ahwesh's collaborator, Keith Sanborn. Gender is so much the organizing principle that this particular male author, my specialty being relatively tame representations of men loving men, feels somewhat an outsider, slightly confused but honoured by the challenge to write much or little sense about it all.

The thirteen films and tapes can be looked at from two different angles, first as documentary and then, but only then, as eroticism. (And who knows which angle was the most scary for arts funders?) An unacknowledged documentary tradition has been of primary importance for the feminist and avant-garde cinema and video of the past generation. Half of the films and tapes in *Much Sense* are structured more or less on the documentary idiom that my Spielberg-suckled directing students would pejoratively call "talking heads." Of course sex doc poses very distinct aesthetic and ethical problems for talking heads: accordingly, heads in the show may be

13

Below-the-frameline bodies in **LORNA BOSCHMAN'S**
Scars (1987) video still

disguised by masks *(Mirror Mirror)*, below-the-shoulder framing
(Scars), silhouettes *(Khush)* and actresses *(Skin)*. Yet the testimonial
impulse of the political cinema launched in the late sixties (the New
Left, the women's movement, minority rights and lesbian/gay liber-
ation) is present all the same. Interestingly, even Benning and
Snider, two artists who operate furthest from documentary codes—
Benning's baby dyke with her toy camera reinventing Hollywood in
her bedroom *(Jollies* and *It Wasn't Love)*, Snider's all-hung-out
California urban commune members reinventing Sodom in theirs
(Shred O'Sex) —both seem to spend half their time in gigantic head-
on closeup, fogging up the camera lens as if in tribute to the talking
head. However histrionic, this self-portraiture—whether by baby
dykes with painted moustaches or by skinheads who fuck their
skateboards—is documentary without a doubt. I think we will never
be tired of listening to new voices emerging from silence, or of dis-
covering new faces crystallizing in the shadows of invisibility and
stereotype.

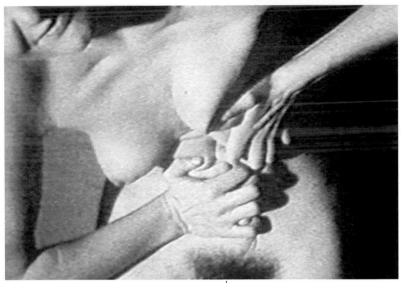

But something else is going on in these works, not just heads talking of the new marginalities, demographies and epidemiologies (women living with AIDS, South Asian lesbians and gays, institutional survivors ...). In the works that curator Sylvie Gilbert screened in Banff, the testimonial impulse migrates down the treasure trail from the talking head to the talking body ... talking arms *(Scars),* talking labia, nipples and frenula *(Stigmata* and *My Body Is a Metaphor),* talking organs and orifices *(Shred O'Sex),* talking skin *(Francesca Woodman).* If the original sixties and seventies documentaries on solidarity, consciousness raising and coming-out privileged the gifts of speech and hearing, Lisa Steele realized as early as 1974 *(Birthday Suit—with Scars and Defects)* that the bodily sense of touch and feel was also emerging within the iconography of liberation, that the body was becoming a new organ of speech, a new performative apparatus of survival, empowerment and communication. That she did so the morning after the partial decriminalization of sodomy, abortion and prostitution in many western countries—a full dozen years before the earliest other work in this exhibition—was prophetic. Steele's conceptual adaptation of

| A mask in **PAULA LEVINE'S** *Mirror Mirror*
(1987) video still

body and performance art may have been taped deadpan in a
rarefied white studio in the seventies, but it anticipates the gritty
real world inhabited by the palpable, malleable bodies that are the
raw material of the eighties and nineties.

Steele's tape is also the link between the more conventional doc-
umentary works in this show *(Mirror Mirror)* and those stemming
from entirely different formal directions and cultural roots: the
erotic tale *(The Deadman)*, the porno film *(Shred O'Sex)*, the home
movie (Benning's two tapes), the comic sketch *(Ten Cents a Dance
[Parallax])* and the found footage mosaic fleshed out with the med-
ical micro-film *(My Body Is a Metaphor)*. The heads may talk
compellingly and proudly in all of these works, but it is the bodies
that really speak. It is no accident that the past decade has seen dia-
loguing penises in European features (the French *Marquis* by Henri
Xhonneux, 1989, and the German *Me and Him* by Dorris Dorrie,
1988), not to mention singing assholes (*Zero Patience* by John
Greyson, 1993) and all-singing, all-dancing vulvas (*We're Talking
Vulva* by Shawna Dempsey, 1990). Bodies pulsate in the universe of

| Homoerotic veils and careesses in **PRATIBHA PARMAR'S**
Khush (1992) shown in front of the homosocial swirlings
and stampings of a rear-projected 1948 Madras potboiler
Chandralekha; still from video transfer of 16 mm film

the spectacle to claim authenticity and pain; in the midst of a cul-
ture that invented cyberspace, Schwarzenegger and mammary
implants, bodies ask, do we not really bleed, scar, throb and swell?

Bodies, yes—genitals, orifices, epidermises galore—but erotics?
What exactly is meant by the subtitle *Erotics and Life?* Did anyone
actually get turned on up there in Banff other than the bigots in the
media and the Cabinet? A pity that the local audiences for the film
and video screenings were not larger, for some would expect that
Albertans whose annual tourist extravaganza is the binding,
spurring, racing, harnessing, whipping, taming and barbecuing of
large mammals would find the branding and harnessing of humans
(Stigmata) pretty hot. In any case, I might otherwise have been
tempted to pronounce prematurely that, for most viewers, most of
Gilbert's films and tapes are *about* erotics without *being* erotic. Even
those works that most blatantly borrow the familiar textual conven-
tions of visual eroticism *(Shred O'Sex, Khush)* might be thought too

|SADIE BENNING'S "burlesque" exhibitionism in
It Wasn't Love (1992) two video stills

self-reflexive, too jokey or too just plain ideological to get the juices
flowing in any sustained way (can politics ever fortify desire?).
Granted, erotic art usually builds on the tension between documen-
tary grain and oneiric mist, but can erotic dreams handle Brechtian
interruptions without getting flaccid?

On second thought, well, yes. Having just finished writing an
out-of-control book on gay male eroticism in photography and film
from their nineteenth-century origins up to 1969[1] —a book that
finds love in all the least familiar places, from ethnography and
exercise instructions to crime detection manuals—I know that any
sweeping generalization about the art of desire is asking for trouble.
In every audience-text interaction bloom a hundred turn-ons.

If we compare *Much Sense: Erotics and Life* to those twentieth-
century traditions of film, photo and stage eroticism that an
amnesiac culture and Canada Customs want us to forget, echoes
and continuities abound. Indeed most of the artists in the show use
tried and true erotic vocabulary. The great theatrical tradition of
burlesque, for example, was based on the exhibitionist strutting,
wisecracking and self-consciously staring down the audience that
Snider and Benning sew into *Shred O'Sex* and *It Wasn't Love* respec-
tively. As for the radical body alteration of *Stigmata,* it mimics the
obsessive body-sculpting of the physique pose films that used to
turn on our gay ancestors in the fifties and sixties; at the same time,
its sense of women's bodies reinvents the seventies West Coast
lesbo-erotica of Tee Corrinne and Barbara Hammer, but also winks
at the gynecological hyperrealism of *Penthouse*-style centrefolds.
The talkfests like *Mirror Mirror, Scars* and *Ten Cents a Dance
(Parallax)* all unwittingly recall a short-lived genre of the mid-six-
ties, when the censors allowed words to outpace images and strange
dirty-talk movies (women talking about their below-the-frameline
bodies) briefly became a staple of the United States soft-core
industry. One of Onodera's cunning setpieces targets the phone sex
trade, an industrialized revival of that dirty-talking tradition. Even
Parmar, in many ways the most chaste, but also the most sensuous
of the artists, explicitly reclaims earlier genealogies of eroticism, not
underground this time but mainstream: swirling veils, stamping

anklets, filtered light and tropical homosocialities via the Bombay-Madras film industry of her ancestral homeland.

There are also memories of the underground. Everything from the earnest masks of *Mirror Mirror* to the artisanal spontaneity of Snider and Benning, complete with tacky felt pen title cards and low-definition black-and-white formats, reminds me of pre-sexual revolution, clandestine traditions in which signifiers of shame, hand-developing and toy technologies were the norm. In fact, as I argue in my book, such undergrounds were fundamentally political in their formation of oppositional community. Who could deny that the sleazy Polaroids and murky eight-millimetre films of the pre-Stonewall fifties anticipated the new women's media and performance arts of the eighties in their enactment of taboo desire?

As for the avant-garde, sex has always been too important to leave to the underground and the mainstream: cycles of utopian erotic obsession have marked avant-garde history. Kate Thomas' luminous black-and-white epidermal landscapes recall more than one prehistoric avant-garde film, for example Willard Maas' *Geography of the Body,* made in 1943. Ahwesh and Sanborn include affectionate homages to two vintage epics of sex and death that epitomize earlier golden ages of the erotic avant-garde, the anarchist surrealism of Bunuel's *L'âge d'or* from 1930 and the East Village flower-child hysteria of Jack Smith's *Flaming Creatures* from 1965.

Finally, *Penthouse* is not the only artifact from after the so-called sexual revolution to be appropriated and transformed in this show. Ahwesh and Sanborn evoke in *The Deadman* not only the Sadeian universe of excess and satiation borrowed via respectable French pornographer Georges Bataille (author of the story they adapted). They have absorbed also, no less than Snider's lecherous room-mates, the commercial hard-core films of the seventies that Linda Williams found to be safe enough for her scholarly feminist analysis fifteen years later in *Hardcore: Power, Pleasure and the Frenzy of the Visible.* In particular, those two canonic insatiable "nymphomania," *Deep Throat* and *The Devi* (both released in 1972), hover over the work, now turned on their heads (as it were) to become an oddly exhilarating fable of a woman who shouts for whisky and fucks her brains out. As for Friedrich's

| COLIN CAMPBELL, *Skin* (1990) video still:
documentary talking head disguised by actress

lurid micro-closeups of pulsating vessels and gaping valves, their
erotic lineage seems closely related, with just a touch of right-to-life
foetus pornography thrown in for good measure, just the kind the
late Tory Family Caucus loved.

I mentioned gender at the start of these reflections and somehow
must come back to this unspoken organizing principle in conclu-
sion. What does it mean that the few men represented in Gilbert's
selection serve as accessories or amanuenses? Campbell's *Skin* is
atypical of his work in its dramatization of transcripts from women
living with AIDS; and, other than Sanborn, the only other male
film/videomakers are Snider's male housemates, pumping and
primping as uncredited supporting performers and co-authors in
Shred O'Sex. As for gay men, we may not be absent from the large
and small screen in this panoply of bodyworks, but on reflection we
are unexpectedly scarce behind the camera (is it because of Canada
Customs' ban on anal penetration, or is the government of Alberta's
right wing claiming we do not exist?). In fact this scarcity is notice-
able because the work of such gay artists as Bruce LaBruce, Marc

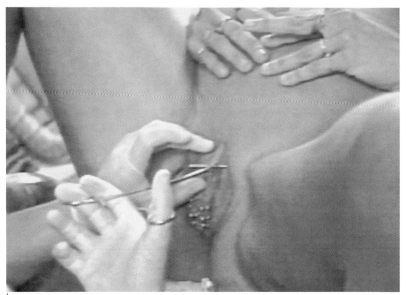

│LESLIE ASAKO GLADSJO'S *Stigmata* (1990) video still:
reinventing 1970s West Coast lesbo-erotica and winking
at *Penthouse*-style gynecological hyperrealism

Paradis and John Greyson—to name only a few Canadians who
come to mind—would have fit perfectly.[2] After all, gay male
filmmakers and video artists can be seen as pioneers in the arts of
the body. Moreover, as Gilbert recognized in programming *Skin* and
My Body Is a Metaphor, the AIDS pandemic has sparked corporal
iconographies that bleed into other imagery of body exaltation,
alteration and mortification in the show. Mostly gay male HIV posi-
tive and PWA (Person with AIDS) artists as diverse as Carl George,
Andy Fabo, Greg Bordowitz and the late Marlon Riggs, Tom Joslin
and Esther Valiquette (an amanuensis of sorts for a gay male PWA
in her first work) have all demonstrated this continuity again and
again.

 Noticing such patterns is not to take away from the urgent pri-
ority of focusing on the women's voices and images reshaping the
vocabularies of bodies and sexualities in the eighties and nineties. It
is about "taking our power back," says the tattoo artist from
Stigmata, about dealing with "visible stuff rather than internal stuff

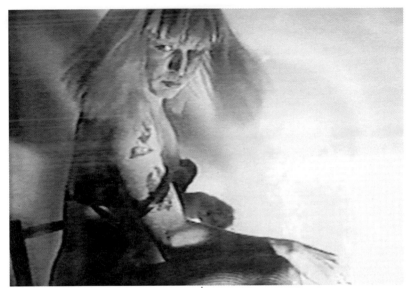

STASIE FRIEDRICH, *My Body Is a Metaphor*
(1992) video still: new corporal iconographies
sparked by the AIDS pandemic

I can hide," says one of Boschman's scarred heroines. The last thing
we need is yet another man griping about exclusion from women's
space. Yet such a strict gendered focus can be hard to maintain in
the current context. After all, Onodera, Ahwesh, Snider, Friedrich
and Parmar all could not resist incorporating male homoerotic
imagery in their works in the show, and I for one am delighted with
this "appropriation." Dialogue is continuing to open up as fast as the
thighs in these works, and the Michigan Womyn's Music Festival,
in a symbolic landmark year, finally opened its gates to transsexuals
in 1994. On some level, at least in terms of bawdy and body images,
biological gender essentialism may make less and less sense.

Erotics and life, sex and documentary, the gendered and trans-
gendered body theatre of bedroom, street and imagination are what
this show is about. As it happened, the Alberta media lynch mob
focused on the Kiss & Tell "lesbian performance" and symptomati-
cally paid scant attention to film and video. No need to feel left out,
for I have a hunch that some of the bad-girl hetero stuff would have

frightened the horses of the patriarchy even more (Ahwesh, Snider and above all Gladsjo's shot of the phallus itself being pierced). Whenever our endemic crises in sexual politics converge with crises in socio-cultural politics—radical sex versus family values, an urban "tiny coterie of grant-hungry artists" and "anarchists in the subsidized arts clique"[3] versus defenders of populist, nativist and rural politics within a downturned economy—the shit really hits the fan, and outlaws, marginals, subalterns and so-called elites are scapegoated. It is ironic that while avant-garde artists are systematically exploring pop forms, and while audience and distribution are becoming deep-rooted concerns of artist-run outfits, the polarization between artists and the so-called mainstream has been exacerbated.

It may be that the AIDS pandemic has widened the rift of fear and loathing. The new imagery of bodies—fluids, membranes of tissue and latex, cells, lesions, hollow eyes and loose skin—is largely absent in most of the works in this show (although Ahwesh inserts a condom that was not in Bataille's original story ...). But HIV is present as a profound shivering absence all the same. Is AIDS behind the propensity of several of these artists to link the eroticization of the body with its mortification, sex with pain and death? Whatever the reason, women artists' appropriation of sexual imagery, their use of the body as a blank screen and malleable clay, is a political ultimatum that the powers that be understood all too well. This body on which we carve our revolt and register every sensation, this body from which we squeeze every drop of pleasure and pain and reach out every gesture of community and autonomy, this body is a battleground—not only against the virus, but also against censorship, conformity and control. In the province of the hyperreal and the all too REAL Women, our bodies are not metaphors.

Fall 1994

NOTES

1 *Hard to Imagine: Gay Male Eroticism in Photography and Film from their Beginnings to Stonewall* (New York: Columbia University Press, 1996).

2 The late Robert Flack's presence as one of three visual artists featured in the installation aspect of the show brought genders closer to balance, as well as stepping up gay male visibility.

3 Headlines in *Alberta Report* (1 March 1993).

Sometimes the events provoked by an exhibition provide as much insight into our culture as the works in the exhibition themselves. One such instance provides a good illustration of the kinds of furor that have surrounded exhibitions of erotic art in North America in recent years.

Close Cover before Striking

Sylvie Gilbert

The Walter Phillips Gallery is part of a large art institution nestled in the Canadian Rockies—The Banff Centre for the Arts, which in turn is part of The Banff Centre for Continuing Education. The gallery has been active for the past twenty years, and its primary mandate is to present contemporary art. Most of its exhibitions are organized by curators on staff, most of them are group exhibitions and most are conceived around themes. The gallery has a reputation for presenting original research in a challenging way. The relative liberty the gallery has enjoyed over the years compared with other public institutions is mainly due to the fact that the primary audience consists of artists resident at the Banff Centre and artists living in Calgary and Banff. In addition, a steady trickle of tourists visit during the winter, and the numbers swell in the summer with the influx of visitors to Banff National Park, where The Banff Centre for the Arts is located.

In the spring of 1992, I initiated research for an exhibition to be organized around some of the themes now understood as sexuality/eroticism/desire. The idea for the exhibition came in discussion and collaboration with my colleagues in the residency programs then called Art Studio and Photography Studio, now replaced by the Media and Visual Arts residency. Art Studio was programming a residency on the feminist subject while the Photography Studio was inviting artists who dealt with issues of masculinity. I was doing the sex show.

The final selection of artists in the exhibition was based on a desire to include work that questioned sexual representation in

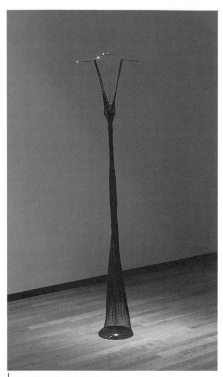 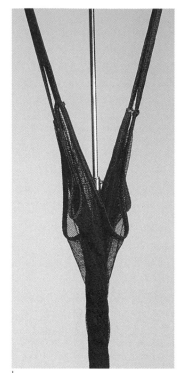

| MAUREEN CONNOR, *Thinner Than You* (1990) installation view

| MAUREEN CONNOR, *Thinner Than You* (1990) detail

diverse mediums, different sexual orientations and multiple points of view. I was specifically interested in how desire is represented and how artists choose to interpret or address desire within different contexts.

In the gallery space we presented the work of Maureen Connor, Kiss & Tell and Robert Flack. A performance by Kiss & Tell was also scheduled as part of the exhibition. In addition, a film and video series included the works of Peggy Ahwesh and Keith Sanborn, Sadie Benning, Lorna Boschman, Colin Campbell, Stasie Friedrich, Leslie Asako Gladsjo, Paula Levine, Midi Onodera, Pratibha Parmar, Greta Snider, Lisa Steele and Kate Thomas.

In the exhibition space, a reading area was installed where visitors could find various types of literature, featuring articles, essays

| **KISS & TELL,** *True Inversions* (1992) detail

or images of sex—fashion magazines, fiction and theory books, journals on queer politics, catalogues of eighteenth-century French painter François Boucher's work, erotic Japanese prints and so on.

The artists in the exhibition spent time at the Banff Centre, installed their works, gave presentations and met with other artists in the residencies. Before the opening, I gave a couple of radio interviews and met with a journalist from our local paper. The discussions were sensitive and the questions were intelligent and informed. I was pleased with the mature tone of the interviews.

Contemporary art exhibition titles are problematic most of the time because the promise they hold is often too encompassing. In a modest institution with fast-paced programming, titles are often confirmed, for publicity purposes, before final works are selected or commissioned works completed. Potentially misleading titles create expectations for viewers and fail to make sense of what is finally gathered and installed in the space. *Much Sense: Erotics and Life* was an example of that. However, I had deliberately included the word *erotic* to inform people of what they were about to see. *Erotic* was the word creating the context. While I was installing the exhibi-

You could all be gay bashers for all we know.

KISS & TELL, *True Inversions* (1992) detail

tion, there were a few brief moments when I wondered how visitors would react to the works. What about this photo of an erect penis or that image of a naked woman laced in chains or the word *fuck* written in chalk on the gallery walls? Was it erotic?

On the evening of the opening, oysters were served, candles were lit and loud disco music was played throughout the gallery— Madonna had just released her *Erotica* tape and it was a perfect fit. As usual, a large number of people attended the opening, and everybody had a good time on the large swing in Kiss & Tell's installation.

In preparation for *True Inversions,* the performance by Kiss & Tell, we made contact with gay and lesbian groups in Calgary and Edmonton. In half a day the hundred seats available for the evening performance were completely reserved. (In Banff an art performance usually attracts forty to fifty people.) The artists believed that it was important to add a second presentation and quickly organized their team to present two performances back to back. They did not care about an additional artist fee or that it would require more work. They were excited and proud of the interest. The response on the night of the performances was strong. While some people left, others stayed for the second presentation. All in all, the evening was considered a success.

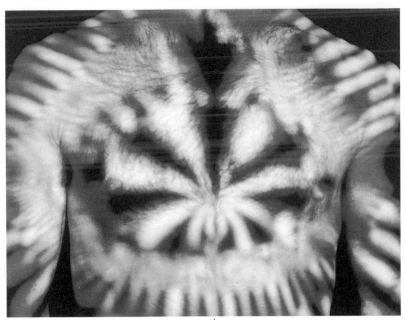

| ROBERT FLACK, *Love Mind* (1992) detail

A few days before the performance, a journalist had called me to
reserve a seat. I asked for whom he was writing. He informed me
that he was a freelance journalist and that he had nothing
confirmed yet. On the evening of the performance, at the end of the
first presentation, the same journalist asked to see the exhibition. I
explained that the gallery was closed because we were using the
swing—one component of the installation—for the performance,
and that made the installation in the gallery incomplete. I invited
him to come back another day when I could walk him through the
exhibition, and I offered to send him a press kit. It was at this
moment that he asked, with a straight face, "I wonder if Jeanne and
Peter Lougheed have seen this shit?" (The performance was being
held in the Jeanne and Peter Lougheed Building.) I realized then
that the journalist probably did not want to understand more about
the exhibition, the performance, the artists or the works. I

| ROBERT FLACK, *Love Mind* (1992) detail

remember asking him about his motive for making a one-and-a-half-hour drive from Calgary, in the snow, to see the performance. Had he ever seen other exhibitions at the Walter Phillips Gallery? No? Then what had attracted him? I suggested that he might have come to the performance enticed by the title, and explained that this in fact was exactly what the project was about—to understand our fascination with sex. I then suggested that, to be fair, he should mention in his article his reason for venturing to Banff for this art exhibition but no others.

For the first week of the exhibition, rumours were flying right and left. One of them was that a Banff Centre employee had lodged a complaint about the nature of the work exhibited. Cafeteria conversations meanwhile converged around a specific photograph in Robert Flack's installation: "the bum shot" to use Flack's phrase. The photograph shows the anus of a man on which is projected a colourful design. This part of the body is in fact one of the seven chakras, the Tantric sites of energy of the body. It was the only com-

plaint received about the
work in the gallery at that
time. But there were
rumours and murmurs
across campus, so we
decided to organize an open
forum, to be held the next
day at lunchtime. Posters
were printed and put up
around campus in no time.
Only ten people gathered in
the gallery, none of whom
raised any objections to the
work presented.

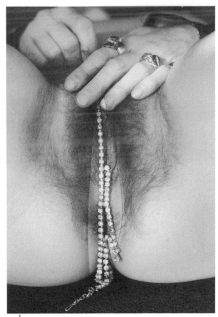

On 7 December 1992, in
the Edmonton-based maga-
zine *Alberta Report,* we read:
"Kissing and Telling in | KISS & TELL, *True Inversions* (1992) detail
balmy Banff: Banff hosts the
latest in subsidized 'alien-
ation' and lesbian porn." Rick Bell, the freelance journalist I had met
the night of the performance, had confirmed a publisher.

Welcome to the roller-coaster ride!

The next day the province erupted. Radio shows debated the
morals of lesbian sexuality. Callers who had not seen the perfor-
mance had an opinion on the event, which by then had become
masturbation on stage. The telephone at the Banff Centre began
ringing off the hook, and civil servants from the Department of
Advanced Education (the funding body for the Banff Centre) con-
tacted the institution. It was agreed that, from that point on, the
communications department of the Banff Centre rather than the
gallery itself, would handle all calls, complaints and interviews
about the show.

It's worth noting that Ralph Klein had just come into leadership
of the Conservative government on a platform of deficit slashing.
Rick Bell wrote: "As usual the money for this free-admission spec-
tacle came from the empty coffers of indebted governments."[1] The

| KISS & TELL, *True Inversions* (1992) detail

exhibition had now acquired a specific identity. In addition to its initial investigation of the erotic in recent artistic production, it became for the press and its audience a lesbian event. It was an ominous exhibit for those with Bible Belt family values. Some threatened to mobilize citizen demonstrations in front of the gallery.

For art controversy to erupt, suggests American sociologist Steven C. Dubin, "a combination of two critical elements is required ... there must be a sense that values have been threatened, and power must be mobilized in response to do something about it."[2] Speed and volume are essential factors as well — how fast events unfold and how loud agitators respond must be taken into consideration. If the same back-and-forth arguments were occurring at a slower pace in the usual tones, we would call it a public debate.

The newspaper coverage lasted for weeks and the attack unfolded on three fronts.

The first one was in response to Rick Bell's article in *Alberta Report*. It was rewritten into a column by Kevin Avram, then with the Canadian Taxpayers Federation, an advocacy organization for taxpayers.[3] His article was picked up by about twenty community papers that receive a newsletter from the Canadian Taxpayers Federation as a feature service. The articles were published between 31 December and 18 January in Alberta and neighbouring provinces.[4]

The second attack came on 13 January, when Deputy Premier Ken Kowalski was interviewed on a CBC morning show, qualifying Kiss & Tell's performance as "God-awful," and an "abhorrent lesbian show." He wanted the Banff Centre to stop spending taxpayers' money on such events and "urged Advanced Education Minister Jack Ady to help put an end to the homosexual shows at government funded institutions."[5]

Kowalski's declaration was met with opposition from members of Alberta arts communities, representatives of cultural groups and the Alberta Status of Women Action Committee, and was published in newspapers from 15 January to the end of the month.

If lesbian art was reported as being offensive to taxpayers' morals, Kowalski's unequivocal comments created an uproar in the cultural community, whose members also regarded themselves as taxpayers. Kowalski was horrified that lesbians were visible. Artists reacted to this moral majority position: they were shocked, their activities support an economy and, yes, lesbians pay taxes.

The third phase of the response to the "Banff masturbation show," as it became known, emerged in the following weeks in the form of an increased focus on cuts to the arts in Alberta. The government was in a scolding mood and, in the logic of the time, artists were labelled special-interest groups. In such bad economic times, people were saying, there should be no funding for special-interest groups.

Rick Bell joined the campaign, too. He interviewed Labour Minister Stockwell Day when both attended the Canadian Taxpayers conference in Calgary.[6] On 24 January his article in the *Calgary Sun* titled "Culture grants painted black" opened with "Alberta taxpayer funding for culture should end, says Labour Minister Stockwell Day." He continued by deploying the populist belief that cultural grants support "areas of special interest privilege" and more specifically that "a group of lesbians have the right to express themselves as long as they do not break the law, but they shouldn't do it by taking money out of my wallet."[7] These published comments set off a number of reactions—this time mobilizing groups fighting for the recognition of gay and lesbian rights. The

ROBERT FLACK, *Love Mind* (1992) detail

threats of cuts to culture pro-
voked protest rallies
throughout Calgary and
Edmonton, spearheaded by
the Calgary Professional Arts
Alliance and the Edmonton
Professional Arts Council. In
Banff, various arts groups,
artists and supporters joined
in a demonstration.

One afternoon during
that period, I was sitting in
my office listening to the
CBC afternoon radio pro-
gram "Wild Rose Country."
The phone lines were
opened and the question to
the audience was, "Should
gays and lesbians have rights?" I felt sick to my stomach. However,
it was then that I realized that the exhibition had been a decisive
moment for the social psyche of Alberta, when art, lesbian visibility
and taxes—a volatile trio—had started on a collision course. My
only consolation was that at least the issues were out of the closet. I
believe the exhibition made the covert agenda of the government
clear to the public and provided a chance for the opposition to orga-
nize itself and articulate its argument.

The series of protests must have taught the politicians the advan-
tage of silence: no more public statements were made. However, in
late 1993, the Alberta Foundation for the Arts, the provincial arts
funding body, introduced a clause on its grant form stating that its
board of directors could refuse funding for an exhibition. According
to government employees, this had always been the case, but it was
now being made explicit in the grant guidelines because the polit-
ical climate demanded increased accountability for public funds.
Funding for operations grants for public galleries is now in part pro
rata (allocated based on the number of Alberta artists presented).

In the fall of 1994, almost two years after the first media coverage of the controversial performance in Banff, Community Development Minister Gary Mar was still introducing policies qualifying art by morality. In effect, he proposed a new rule in the funding game: if your exhibition, dance or play would be deemed obscene by the court, the government would have the right to "ask for its money back." In the course of a political dispute, Deputy Premier Kowalski was relieved of his duties, the Cabinet was reshuffled and the proposed motion was dropped.

| ROBERT FLACK, *Love Mind* (1992) detail

This exhibition presenting the work of a handful of artists could not counter the hatred expressed by a number of politicians and some journalists. What curators have at their disposal, however, is the potential to open up the analysis of such events and organize, within institutions or independently, more exhibitions and public talks and to publish catalogues as well as books. With this controversy—as with most controversies—paradoxically the media assumed the position of an audience, one that in fact never saw the performance, the films, or the exhibition in the gallery and insisted on making public opinion. The controversy surrounding the presentation of the exhibition *Much Sense,* when looked at in retrospect, seems foolish; however, on closer examination it provides a window to observe the structure of public opinion-making both provincially and nationally. Within institutions, the effects of a controversy over time are not negligible. When they arise, they are often perpetuated

in the form of oral history, remembered and murmured in whispers. Most of the time they are used covertly to deter further activities perceived as problematic by those hesitant to take risks. It is my hope that the included essays and reprint of the press coverage will allow the contestation among competing publics to be known.

Spring 1995

| MAUREEN CONNOR, *Wishing Well* (1990) detail

| MAUREEN CONNOR, *No Way Out* (1990) installation view

1 "Kissing and Telling in balmy Banff," *Alberta Report* (7 December 1992), 33.

2 Steven Dubin, *Arresting Images: Impolitic Art and Uncivil Actions* (New York: Routledge, 1992), 6.

3 Kevin Avram refused permission to reprint the article in this publication.

4 *Lakeside Leader,* Slave Lake, Alberta
 The Advocate, Athabasca, Alberta
 Jasper Booster, Jasper, Alberta
 The Hanna Herald, Hanna, Alberta
 Smoky River, Falher, Alberta
 The Central Peace Signal, Rycroft, Alberta
 The Hamiota Echo, Hamiota, Manitoba
 The Rossburn Review, Shoal Lake, Manitoba
 The Birtle Eye-Witness, Shoal Lake, Manitoba
 The Shoal Lake Star, Shoal Lake, Manitoba
 Neepawa Banner, Neepawa, Manitoba
 The Daily Graphic, Portage la Prairie, Manitoba
 Opasquia Times, The Pas, Manitoba
 West-Central Crossroads, Kindersley, Saskatchewan
 The Watson Witness, Canora, Saskatchewan
 The Optimist, Redvers, Saskatchewan
 The Swift Current Sun, Swift Current, Saskatchewan
 The Nipawin Journal, Nipawin, Saskatchewan
 Comox District Free Press, Courtenay, British Columbia
 Clearwater/N. Thompson Times, Clearwater, British Columbia
 Omineca Express/Express Bugle, Vanderhoof, British Columbia
 The titles for these reprints were changed by the respective newspapers and varied between: "Taxes pay for lesbian show," "Let's talk taxes," "Tax dollars at work," "Even lesbianism is government funded" and "Funding ménage-à-trois."

5 Jeff Harder, "Tax-funded gay sex play 'God-awful,'" *Edmonton Sun* (15 January 1993).

6 In the *Calgary Sun* of 31 January 1994, under the title "Picture of controversy: Art forms focus of heated debate," Rick Bell published another commentary rolling together the subjects of artwork purchased by the National Gallery of Canada, grants to artists and taxpayers' money. If one looks closely at the credits under the photographs of the artworks used to illustrate "controversial art," one notices that all except one are courtesy of the Association of Alberta Taxpayers. This last detail suggests a connection between the Association of Alberta Taxpayers' agenda and Bell's role in the journalistic life of the province.

7 The *Calgary Sun* article is reproduced on page 52.

The Media Debate

Alberta Report/7 December 1992

CULTURE

Kissing and Telling in balmy Banff

Banff hosts the latest in subsidized 'alienation' and lesbian porn

By Rick Bell

A lineup of excited frolickers gathered on a cold, snowy night three weekends ago in Banff. These weren't mountain-bound yuppies waiting for the next chairlift or Japanese tourists queuing up for a Big Mac and a made-in-Hong Kong mountie doll. No, these were the resort's culture crowd: leather-clad art afficionados with spiky short haircuts searching for the ultimate meaning of lesbian sex, courtesy of The Banff Centre for the Arts and the Alberta taxpayer. What they got was a postmodern art adventure, much preaching about how hateful and nasty straights oppress with-it lesbians, and movie footage of the artists masturbating.

Kiss and Tell, a troupe of three Vancouver lesbians, put on the 90-minute film and live talk performance "True Inversions" as part of the Centre's three-month exhibition "Much Sense: Erotics and Life" at the Walter Phillips Gallery. Gallery curator Sylvie Gilbert calls it "an educational expe-

rience." She feels it draws attention to the enigma of sex: "It's the thing we are fascinated with but we have been taught not to talk about it."

Kiss and Tell suffered no such claustrophobic inhibitions. "Interdisciplinary artist" Lizard Jones accompanied by sculptor Persimmon Blackbridge and performance artist Susan Stewart felt their art would "explore the complexities of lesbian sexual pleasure" because "sex and the world are intricately complicated" and "what we do in bed is influenced by where we come from." Sexual pleasure, explained the Kiss and Tellers, "is interrupted by," among other ills, "male violence, sexism, and state control of our bodies and our art." The lesbians were nonetheless a bravely gay lot. "There is still joy which we affirm alongside our pain."

The show took place in the crowded, darkened theatre of the Jeanne and Peter Lougheed Building while an overflow audience waited outside for a second performance scheduled at the last minute. The former premier and his wife were not in attendance. One woman with a nose ring, army boots, and a shaved hairdo in the style of Irish pop singer Sinead O'Connor, chatted about her visits to "alternative" clubs in New York. Another proudly displayed her "That's Ms. Dyke to You" button. The audience was mainly female of the military crewcut variety. Black leather jacket, black miniskirt, black tights or black fishnet stockings and black army

boots or runners in orange or green were the prevalent fashion statement.

The lights went on and the three artistes approached microphones. With photos of nude women projected on a screen behind them, the performers shared their fantasies and experiences of sex with other women. One said breathily, "My lust is huge and uncontrollable" for any woman in a white lab coat. She felt a desire "in a centre that weights in my [bleep]." She was obsessed with "my desire to [bleep] her and for her to [bleep] me." Another rattled on about "femmes" and "butches," while a short-haired woman with a rubber pig nose, schoolboy's cap, long leather coat, work gloves and huge boots sang; during all this the performers stripped, putting on other clothes taken out of suitcases.

One of them then donned a fake moustache and cowboy boots and spoke about "his" outrage against pornography since "his" conversion to Jesus Christ, while a cleaning woman romped around the stage and the third performer blew a whistle. The crowd roared.

The artists also showed a film featuring one of the performers rollicking with her "butch" girlfriend, another masturbating while she talked about her first sexual experience, and a third appearing as a sexually repressed "square" whining petulantly that sex with other women "was not fun, it makes me feel weird." The crowd again roared.

Religion got a beating. On film a woman writhed on a bed, reverted to childhood, and bitterly addressed a "Reverend Daddy" who spoke "a pack of lies" and "bore into my eyes when you clutched my hand." The woman intoned that she does not want to be like her mother "beaten down and dowdy, ready to betray her daughters for Daddy."

After some standard-fare lesbian porn films, the performers in turn read out letters to their families about their feelings, while others sat on a gigantic swing set. The audience loved it all, bestowing overwhelming applause at the end and two curtain calls.

As usual, the money for this free-admission spectacle came from the empty coffers of indebted governments. The Walter Phillips Gallery is part of the Banff Centre, bankrolled this year with $14.5 million by John Gogo's Department of Advanced Education. The gallery itself got at least another $15,000 from Doug Main's Department of Culture and Multiculturalism this year. Statistics on how much taxpayers contributed to this show in total are apparently secret. The gallery curator could not answer inquiries about money, and over in the Banff Centre's "communications department," "Todd" (who was too uncomfortable with the question to divulge his last name) wouldn't say. As for Kiss and Tell, it is funded by the federal Canada Council.

LETTERS TO THE EDITOR

Doug Main, for the record

Your magazine's slavish devotion to point-making at the expense of good journalism is nowhere more evident than in the article in the December 7th, 1992, issue: "Kissing and Telling in balmy Banff."

The story and the accompanying cartoon suggest I am personally responsible for, and supportive of, and am even "proud" to be involved in the dissemination of the views presented at the event and that I personally finance the operation of this group.

Your ignorance of the facts, either deliberately or as a result of non-existent research, speaks amply to the value readers should place on the entire range of articles in your magazine. I want to set the record straight for you, your readers and the general public.

The minister of culture is not the arbiter of taste in Alberta. His responsibility among other things, is to provide support for the infrastructure that allows for artistic expression. That includes operational grants for public art galleries, theatres and other venues. It includes support for individual artists and artistic groups as well as various media for expressing art such as publishing and filmmaking.

Maintaining this kind of support is viewed as worthwhile by many people who see quality of life and cultural expression as important aspects of society. It is not as important as health care or good education and that reality is evident in the amount of money spent, roughly .02% of the total budget.

For your writer to extrapolate longstanding departmental support programs into my personal support for "Kiss and Tell" or any other artistic event strains credibility to the breaking point. It's intellectually and journalistically dishonest to blame me for every performance, printed work, frame of film or canvas that doesn't meet your standards of acceptability just as it is to credit me for those things that do.

Why didn't someone call and find out that the $15,000 to the gallery is an annual grant of lottery money from the Alberta Foundation for the Arts, based on an analysis of the gallery's budget. It represents about 3% of the gallery's $500,000 annual expenditures. Why didn't someone call to find out that there was no direct support for "Kiss and Tell."

By the way, I think the event and its line-up of performances was disgusting. I wasn't asked to provide any special specific funding for this event. If I had been asked I would have said "No!"

—*Doug Main,*
Minister, Culture and
Multiculturalism

Alberta Report / 21 December 1992

LETTER FROM
THE PUBLISHER

If Mr. Main wasn't responsible for subsidizing those Banff lesbians, then who was?

Please read the anguished outburst in this week's Letters department from Doug Main, minister of Alberta Culture. Mr. Main was until four short years ago one of the thin-skinned stars of the broadcast industry, and these days he is thinner-skinned than usual. By the time you read this, he will probably have been relegated to the back bench by incoming Premier Ralph Klein, whom Mr. Main ran against and publicly insulted for being a smoker and a drinker. If he is demoted it is probably for the best, and not just for the peace of mind of those who drink and smoke. It will allow him time to think. Mr. Main obviously hasn't the faintest notion what he was put in cabinet to do.

I needn't dwell on his opening assertion that "good journalism" is supposed to be pointless. Mr. Main, as I mentioned, is from television, and ITV paid him to read the stuff, not to understand it. It doesn't seem to have occurred to him that every story rolling through his teleprompter was put there to make some kind of point. Otherwise, his audience would have turned to something more interesting — the latest telephone book, perhaps. We should also view with charity his unhappy condemnation of the "entire range of articles" that we publish, such as the special feature we did on his commendable campaign proposal for voucher education. He has been under considerable stress for the past few months.

The story that has so upset him concerned a performance by a troupe of foul-mouthed, sex-obsessed Vancouver lesbian activists in the Jeanne and Peter Lougheed Building at The Banff Centre for the Performing Arts. There is no need here to recount the sacrilegious obscenities with which they regaled their free-admission countercultural audience for an hour or so; you can check the story. Mr. Main objects that in the final paragraph and in an accompanying cartoon we implied that he was "personally responsible" for what went on because his department helped fund it.

I have news for Mr. Main. He *was* personally responsible for it — and if our story only implied it, let's state it explicitly here and now. He and his co-funding minister John Gogo are the two elected people who must account to the Alberta legislature for the expenditure of tax money for subsidized arts performances at tax-funded

post-secondary institutions. There is no one else who can. The governors of the Banff Centre can't. The directors of the Alberta Foundation for the Arts can't. The curator of the Walter Phillips Gallery can't. The only man who can demand of these people some accountability for their behaviour is the minister who appoints and/or funds them. And he is the one whom political tradition and moral common sense hold duty-bound to explain why we were all forced to pay for such drivel.

Instead, we get the usual recital of cop-outs which cabinet ministers everywhere have made nauseatingly familiar. "The minister of culture is not the arbiter of taste." "It's dishonest to blame me for every performance that doesn't meet your standards." "The amount that government spends on the arts is very small." Can it be any wonder that the mere mention of politics these days turns people's stomachs? If Mr. Main says he isn't responsible for making us pay women to masturbate in public, then who does he think is? Answer, nobody. Shut up and pay your taxes, and leave your betters to decide how they will spend them. That is the Main position.

It is so self-evidently wrong that there is no need to belabour it, and perhaps a cooling-off period in the back benches will enable Mr. Main to contemplate what his letter actually means. In many other respects he has been a good minister: he trimmed his departmental spending, and he re-focused Alberta's multicultural thrust on ethnic integration rather than isolation. But he had really better absorb this very central point about what our system has long called "responsible government." In fact, he and NovAtel minister Fred Stewart could ponder the subject together.

That way, if he ever becomes culture minister again, his first act might well be to send a memorandum to everyone his department funds, and it would read something like this: "Please be advised that as minister responsible for cultural subsidies I am accountable to the voters and taxpayers of Alberta for what you do. When we take their money we owe them the courtesy of respecting common norms of decency and religious tolerance. If you feel otherwise, please look elsewhere for finances. Copies to: the Southham newspapers, the CBC, etc." That would be ministerial responsibility.

—*Link Byfield*

Edmonton Sun / 15 January 1993

MINISTER FUMING OVER SHOW

Tax-funded gay sex play 'God-awful'

By Jeff Harder
Staff Writer

Deputy Premier Ken Kowalski wants The Banff Centre for the Arts to stop holding "God-awful" lesbian exhibitions on its property.

"I most definitely do not endorse this," Kowalski told reporters yesterday at Government House. "It's totally inappropriate."

The Banff Centre, which is funded with tax money and lottery funds, recently hosted the travelling troupe Kiss and Tell — a three-member lesbian group that put on a 60-minute show that included sexually explicit lesbian movies.

Banff Centre spokesman Jon Bjorgum said Kowalski's comments represent a "somewhat redneck attitude. I believe he would have a different opinion if he had the opportunity to see the show."

The December show — staged in the school's Jeanne and Peter Lougheed Building — included testimonials, male-bashing and X-rated lesbian films.

The members of the troupe are clothed throughout the demonstration.

Kowalski is in charge of the lottery coffers.

"Every once in a while they do some of these things that are God-awful in my humble opinion. This is the third (controversial show) I've had to deal with, this abhorrent lesbian show."

Kowalski urged Advanced Education Minister Jack Ady to help put an end to the homosexual shows at government-funded institutions.

"It's incumbent upon the minister directly responsible for that particular body to talk to them and say that is not acceptable," he said.

Although Ady wasn't available for comment, his aide Steve MacDonald said the minister had already contacted the Banff Centre to raise his concerns. "We have been in contact with the institution," he said. "Of course, the minister does not endorse it."

Calgary Herald / 16 January 1993

Kowalski triggers homophobia charges

By Nancy Tousley
(Herald writer)

Alberta Deputy Premier Ken Kowalski's attack on a performance given by lesbian artists has brought charges of censorship and homophobia against the Klein government.

"I wonder where this deputy premier gets the right to censor art in this province?" asks Nancy Millar of the Alberta Status of Women Action Committee. In her opinion and that of people in the Calgary arts community, remarks Kowalski made to reporters in Edmonton Thursday are "completely out of line."

The deputy premier, who was not available for comment, reportedly referred to an art work by Vancouver artists' collaborative Kiss & Tell as "this abhorrent lesbian show" and called on Advanced Education Minister Jack Ady to help stop the appearance of homosexual shows in institutions funded by provincial money.

Kowalski is in charge of the lottery monies that provide funding for the province's cultural institutions. The new controversy he has sparked comes on the heels of another furore, ignited by Community Development Minister Dianne Mirosh's comments on protecting homosexual rights.

The Kiss & Tell performance took place last November at The Banff Centre for the Arts, which falls under Ady's jurisdiction. The work, presented in conjunction with an exhibition at the Walter Phillips Gallery on view through Jan. 24, included videotapes depicting lesbian sexuality and commercial pornography.

"It's a dangerous thing to allow individual ministers to make comments on issues they are not educated in," Millar said.

"We have to note that the Kiss & Tell collaborative uses performance art to foster discussion about pornography, eroticism and sexuality.

"It makes me think that Ken Kowalski and Dianne Mirosh should put together a performance to foster discussion on homophobia, bigotry and hatred," said Millar.

"He's completely out of line. he's not the culture minister. He's homophobic. He wasn't in attendance."

Members of the Calgary arts community echo Millar's opinion that Kowalski's attack on The Banff Centre raises the spectre of direct or self-imposed censorship through funding cuts.

They also agree that a pattern of "ultra-conservative and moralistic

attitudes" is emerging in Edmonton that could have a chilling effect on the arts.

"We want to support the artists' right to present material that could be controversial. We don't want to handcuff them before they start," says Sandra Vida, co-ordinator of The New Gallery, an artist-run centre which receives half of its major grants from lottery money.

Duval Lang of Quest Theatre said he feared that attacks on the arts will make it easier to justify more budget cuts to cultural institutions.

"They are going after targets that produce the most significant aftershock in Alberta communities," he said.

And while censorship or any impediment to freedom of expression is a curse to the arts community, Alberta Theatre Project's Michael Dobbin pointed out the power of recrimination.

"He (Kowalski) will use that, and my board will say, 'You better shut up.' We can't shut up. I think we have to stand up on our hind legs and scream bloody murder, not just for the gay community and the art community but for all Albertans."

Carol Phillips, vice-president of the Banff Centre and director of the arts school, confirmed that the centre had been contacted by the Ministry of Advanced Education.

But she said it happened last December after an article critical of Kiss & Tell's performance appeared in Alberta Report.

An office spokesman for Ady said Kowalski contacted Ady about his concerns. However, the centre is run by an independent board and the issue is considered over, the spokesman added.

Edmonton Sun / 20 January 1993

'Morality' is not the point

By *Valerie Hauch*

In Dianne Mirosh's world, it's OK to fire a competent person from a job simply because she is gay. In Dianne Mirosh's world, it's OK to evict a good tenant, simply because a landlord has discovered he's a homosexual.

Those are the only conclusions one can reach when considering some of the statements made by the new community development minister who's responsible for the Alberta Human Rights Commission.

She's against having gays included in the Individual's Rights Protection Act, which would make the aforementioned situations illegal. At the same time, she's of the opinion (asserted earlier this month) that "it looks as though gays and lesbians are having more legal rights than anybody else."

How the minister is able to figure that being subject to discrimination somehow translates into "extra rights" for gays is an equation only the Mirosh mind is capable of comprehending.

Yup, the Calgary-Glenmore MLA's world is a peculiar one, if not particularly logical (or grammatical).

The whole conundrum arose when the rookie cabinet minister questioned the Alberta Human Rights Commission's recent decision to investigate complaints of discrimination from gays, following an Ontario court ruling that the federal human rights law includes protection of homosexuals. Although it is not necessarily binding on Alberta, the decision did establish a legal precedent.

But is Mirosh's argument against including homosexuals in the Individual's Rights Protection Act a purely practical one, based on the fact she feels they make up a "special interest" group that shouldn't be catered to?

Or is it an emotional one — Dianne Mirosh feels homosexuality is morally wrong?

This writer suspects the latter from the minister who said:

"We're talking about what Albertans feel morally. The majority of Albertans oppose special protection for gays."

Although no one has surveyed Albertans province-wide to see if they want sexual orientation included in the Individual's Rights Protection Act, somehow Mirosh has been able to delve into the minds of us all to come up with her "majority" conclusion.

One suspects that what Mirosh really means, but won't come right out and say, is that she doesn't like what homosexuals do and, because of that, feels they don't deserve legal protection from discrimination.

The same dislike of homosexuals would appear to be behind Public Works Minister Ken Kowalski's comment that a lesbian art show at the Banff Centre school of fine arts was "God-awful."

Unlike Kowalski, yours truly isn't interested enough in lesbian art to see the show, so I can't say if it's good or bad. However, if its apparently explicit nature offends Kowalski, then he should probably also stay out of those bars which feature explicit strip shows, sometimes involving two women.

In actual fact, the "morality" of non-criminal activity between consenting adults shouldn't come into a discussion of gays and the Individual's Rights Protection Act.

The origins of homosexuality are still unknown, although the most recent research indicates that people are born that way. It's not a choice.

Many homosexuals — including those who've grown up in exemplary, traditional homes — say they've always "known" they were gay.

Is it "moral" to punish — and discrimination can be considered punishment — people who are the way they are because of some genetic blueprint?

Religious people will quote Bible passages admonishing homosexual practices as reason to allow discrimination. Well, let's not be selective. Depending on which part of the Bible you want to quote, a case can also be made for stoning adulterers to death and killing others who hold dissimilar religious beliefs.

No matter how much people may dislike what gays do — and this writer must confess she finds certain homosexual practices peculiar, to say the least — it's really their business.

What consenting adults do in private should have no bearing on their jobs or where they live.

Calgary Sunday Sun / 24 January 1993

PROVINCIAL POLITICS

Culture grants painted black

By Rick Bell

Alberta taxpayer funding for culture should end, says Labor Minister Stockwell Day.

"Government should only fund those things the public gives them an overwhelming consensus to fund," Day said yesterday.

"We really have to take a look at the attitude we have of thinking we're entitled to get something at somebody else's expense.

We should look at cutting any special interest privilege paid for out of taxpayers' money."

Day, a Red Deer MLA, was attending the Canadian Taxpayers Conference this weekend in Calgary.

Day singled out two areas of special interest privilege — cultural grants and MLA pensions.

"People in the arts may have a need to express themselves, and that's fine, but not by taking money from the taxpayer.

"A group of lesbians have the right to express themselves as long as they do not break the law, but they shouldn't do it by taking money out of my wallet."

Day was referring to a November 1992 performance by three Vancouver lesbians at The Banff Centre for the Arts which showed videotapes of lesbians masturbating with commercial pornography.

The Banff Centre is under the funding jurisdiction of Advanced Education Minister Jack Ady.

Day also said MLA pensions should be funded by the members — not the public.

"We are a group enjoying a special privilege as well," he said.

"If the plan carries itself, that is one thing, but continuing to have it funded by taxpayers is something people are not happy about."

Liberal culture critic and Calgary McKnight MLA, Yolande Gagnon, said she agrees with government funding for the arts.

"Government should have a role in promoting the arts — they are a part of life, a nourishment of the soul," said Gagnon.

She added MLAs should put more money into their pension plan, but taxpayers should also pay for part of it.

The Alberta Foundation for the Arts, the provincial government's main cultural funding agency, gave away $15.6 million the last fiscal year.

Red Deer Advocate / 25 January 1993

Controls on arts funding proposed

By Advocate news services

CALGARY — Red Deer North MLA and Labor Minister Stockwell Day says comments he made about ending Alberta government funding for culture were taken out of context.

"I didn't say drop arts funding; I support arts funding in general," Mr. Day said Sunday.

Mr. Day said his comments referred only to a November performance by a Vancouver troupe at The Banff Centre for the Arts which featured lesbian sex simulations.

On Saturday, Mr. Day, who was attending the Canadian Taxpayers Association conference in Calgary, told a reporter that the government should look at cutting funds to special-interest groups.

"People in the arts may have a need to express themselves and that's fine, but not by taking money from the taxpayer," Mr. Day said.

"A group of lesbians have the right to express themselves as long as they do not break the law but they shouldn't do it by taking money out of my wallet," he said.

Mr. Day said he wants to discuss with Albertans their ideas on where government funding could be cut. That may include a number of areas including the arts, culture, legislative pensions, or funding to big business, including loan guarantees, he said.

"We have to look at everything we spend and everything people have to pay taxes on and see what changes can be made," Mr. Day said.

In both Edmonton and Calgary, cultural groups expressed anger over Mr. Day's suggestion that arts funding end.

"I was devastated," said Earl Klein, artistic director of Nexus Theatre in Edmonton. "I was so outraged my heart nearly stopped."

Michael Dobbin, production director at Alberta Theatre Projects in Calgary, was equally pessimistic.

"If funding is cut, the human resources will go elsewhere and to reconstruct what we'd lose would take 10 times as much money," Mr. Dobbin said.

Edmonton Sun/26 January 1993

DAY 'HAS HIS FACTS WRONG'

Cuts will kill jobs, artists say

By Timothy le Riche
Staff Writer

Ending arts grants as suggested by Alberta's labor minister would kill jobs, warns the Edmonton Symphony Orchestra's managing director.

"We employ 100 people," said Bob McPhee yesterday. "He's defeating his own purpose."

Labor Minister Stockwell Day suggested Saturday that arts and culture, as well as government business loans and MLA pensions, should be targeted for cuts.

The Red Deer North MLA outraged arts groups across the province by making the statements to a Calgary reporter after a speech at the Canadian Taxpayers Conference.

"Government should only fund those things the public gives them an overwhelming consensus to fund," Day was quoted as saying. "We should look at cutting any special interest privilege paid for out of taxpayers' money."

On Sunday, Day said his comments referred only to a November 1992 performance by three Vancouver lesbians at the govern-ment-funded Banff Centre for the Arts.

He said he supports arts funding in general, but neither arts groups nor businesses should consider themselves sacred in a time of budget restraint.

McPhee noted that arts grants are funded through lotteries, not tax dollars.

"There hasn't been tax-based dollars given out to groups for the last five years," said McPhee.

"His facts are wrong to start with."

The orchestra got $750,000 this year in lottery funding, representing about 16 per cent of its budget. Losing that funding would be devastating, said McPhee.

Dick Finkel of the Alberta Showcase for Performing Arts, which represents theatres and festivals across the province, has written to Day asking that the government make a clear statement about culture funding.

His letter says 3,324 performing arts events in the province last year attracted 2.5 million patrons, generating $4.7 million in business.

Where do you go to sign up?

Re "Kowalski triggers homophobia charges," Nancy Tousley, Herald, Jan 16.

Ken Kowalski has objected to a performance at the Banff Centre produced by lesbians. His major objection was that these people were not entitled to the space because it is paid for by taxpayers. I was astounded. I had always assumed that lesbians, like everyone else, paid taxes. But, obviously from Kowalski's statements they don't pay because they are not entitled to use facilities open to everyone else.

Unfortunately, Kowalski didn't inform us on how to sign up to become lesbians. I and everyone I know would now like to become one. We would also like to know how to apply for tax refunds since we are now discovering we have been lesbians as far back as they stopped paying taxes.

Kowalski's other objection, that the lesbians were promoting their lives, initially made no sense to me. I, like everyone who has even briefly thought about it, realizes that sexuality is not chosen and cannot be promoted. Sexuality just is.

But, it turns out I was wrong. Kowalski has promoted lesbianism so effectively, he has convinced me to switch. I thank him for opening my eyes and saving me lots of money.

—*Donald Robertson,*
Calgary

Edmonton Journal / 27 January 1993

Tory musings have arts boosters worried

By Alan Kellogg
Arts and Entertainment

Get ready for it: *Doug Main nostalgia,* drifting back to those golden, progressive Getty years, when the arts took its rightful place at the big table of life.

• • •

The mission of moving arts issues to the front lines of public policy debate has traditionally been a lonely pursuit, to understate things.

The ascendance of Ralph Klein to the premier's chair didn't seem likely to alter things much, other than perhaps pushing the kettle even further back from the front burner. In a single stroke, Culture lost its status as the lowliest stand-alone ministry to find new life as one part of the lowliest multi-portfolio ministry. It's rare that a team can find itself somehow lower than last place, but here is living proof that pure mathematics can indeed lie.

And although Community Development Minister Dianne Mirosh has already named several parliamentary secretaries to manage other briefs under her watch, Culture hasn't yet found a dancing partner. A high priority? You bet.

Indeed, on surface at least, you'd think the new government would seem to be floating somewhere between somnolence and mild contempt regarding an area that represents a minuscule portion of the provincial budget and even less interest on the street.

And yet, culture has been one of the flash points in the new administration, literally grabbing headlines, garnering national interest and dominating talk radio babble. The first minister in the Klein government *Canada's Greatest Newspaper* chose to profile was none other than Mirosh, attention (deservedly snarky though it was) her predecessor would have loved to have luxuriated in.

Needless to say, all this hasn't exactly gone unnoticed in provincial arts admin circles, large and small. Following Stockwell Day's utterances on the weekend, nervousness about the new government's agenda turned into mainstream fear and loathing. In covering the Ministry of Fun for some years, I can't recall receiving as many calls on a subject from such a disparate group of affected folk.

This, from sources who *never* phone and usually adopt a world-weary approach to their more excitable colleagues. And this isn't the standard whining or pumping for gossip, but genuine concern about a perceived change in the

foundations of government support for the arts in Alberta. Scary stuff, as several put it.

Most of the worrying is of a general nature by definition, but in a least one case, there is some evidence to suggest nefarious tinkering is under way already. Gallery operators who receive individual grants from the Alberta Foundation for the Arts (AFA) for specific exhibitions have had funding ratios drop by 50 per cent, not exactly welcome news.

Even more worrisome, according to a major player, are expected criteria changes that could amount to the AFA denying funding to any exhibition even remotely, potentially controversial. Disapproving comments by several ministers on the subject of a November Banff Centre performance by a Vancouver lesbian trio have not gone unnoticed, goes this train of thought.

So, what is it then?

Do these unusually harsh, even more spectacularly uninformed than usual blatherings herald a new dark age, or is the premier merely just letting his considerable right rump blow off some steam? Is this potential public policy-making or public relations for the rural weeklies? Or — considering the partial backtracking by both Day and Mirosh — could these pronouncements merely be a case of loose lips by inexperienced (putting it kindly) new ministers?

Although I happen to lean to the latter view, there doesn't seem to be much doubt that part of Ralph Klein's re-election strategy will involve placating rural voters by pushing hot buttons. Arts funding is a reasonably easy target, especially when tied into censorship issues as George Bush and Maggie Thatcher did with some success over the past decade. (Klein should recall their fate.) Judging a man by his company, the new premier isn't exactly surrounded by free-thinking, arts-friendly advocates of truth and light these days.

With the future at best uncertain, some sort of public action plan along with the standard back-channel lobbying seems appropriate at this juncture.

For one, we should be told where the opposition parties stand on all of this. Do they possess anything approaching a unified arts policy? Standing up at Question Period isn't enough.

What is the government's arts policy, for that matter? As a major initiative, with Alberta Culture trussed and ready for final dismemberment, arts groups, individual artists, and the rest of us should demand formation of an arms-length arts board/council to distribute provincial funding, as civilized jurisdictions around the world do with great success. A foundation where a minister has potential final say in every grant is a joke, an institution unworthy of the name.

Of course, governments fund such bodies, and no one can guarantee good sense or, fair treatment

will prevail in the Klein or any other administration.

At least creation of an arts board/council is a first step toward a new rational approach to funding. And fighting for its inception is so much healthier than ripping precious (!) hair out over the caterwauling of dopey politicians.

Calgary Herald / 27 January 1993

OUT OF THE WEST

Alberta Conservatives running scared

By Gillian Steward
Southam News

It's chilling, to say the least, to hear the deputy premier of the province announce during an early morning radio interview that taxpayers' money should not be used to encourage "abnormal" lifestyles.

The lifestyles that have Ken Kowalski so riled are those of lesbians and gays.

According to Kowalski it's bad enough that "those people" exist at all. But that the Banff Centre, which receives some of its funding from the provincial government, should be the site of performance art that featured lesbian sexuality, was too much for him to bear.

A few days earlier Dianne Mirosh, the new minister responsible for the Human Rights Commission, said she might restrict the rights of gays and lesbians because they had more rights than other people.

In fact, the exact opposite is true. Albertans who are refused jobs or living accommodation because of their sexual orientation don't have much recourse because they are not included in the Individual's Rights Protection Act, as is the case in most other provinces.

So why have two of Premier Ralph Klein's cabinet ministers decided to make an issue of lesbians and gays?

The performance that so enraged Kowalski was last November.

Mirosh's statements came out of the blue.

Could they be looking for scapegoats? Looking to incite mistrust against some of the most misunderstood and vulnerable people in society?

Governments have certainly done that before when they wanted to take control and look powerful — Adolf Hitler and the Nazis being one of the most memorable examples.

Picking on someone else is also a lot easier than facing your own weakness and incompetence.

And the present government (it may have a new leader but it is the same government that was elected in 1989, and the same party that has been in power for 21 years) has many failings to answer for.

Albertans are still waiting to find out what happened to the millions of dollars that were loaned by the government to one of Peter Pocklington's enterprises and never repaid.

There has been no explanation of what happened to the $600 million of taxpayers' money that was lost by NovAtel.

There are still many unanswered questions about the

government's role in the collapse of the Principal Group of companies and the resulting losses to hundreds of investors.

But picking on gays and lesbians is a lot easier than facing up to these enormous boondoggles.

Kowalski and Mirosh are also hoping to cash in on the support of Reform-minded rural Albertans, some of whom believe homosexuality is a sin and should be treated as such.

Appealing to rural Reformers is important these days because Alberta politics has become a three-way race.

Polls show the Liberals are ahead, particularly in Calgary. But the New Democrats have a firm base in Edmonton. That leaves the rural vote, about a third of the total,

for the Tories. And in a three-way race, only slightly more than a third is needed to win.

So the Tories have succumbed to the politics of desperation, and opportunism, to ensure they stay in power.

This month it was gays and lesbians who were targeted.

Who will it be next month and the month after that? Sikhs, feminists, aboriginals, the disabled, the unemployed, the poor?

If the first few weeks of Klein's regime are any indication, this is a government so desperate to maintain its grip on power it could care less who gets hurt.

(Steward is former managing editor of the Calgary Herald.)

Globe and Mail/30 January 1993

Arts groups unite in protest

Anti-government rally to be staged next week in Calgary

By H. J. Kirchhoff
The Globe and Mail

CALGARY — Nearly 300 Calgary artists, arts administrators and other cultural workers met yesterday to discuss responses to what they view as attacks by Alberta's Tory government on cultural funding and the homosexual community.

The heads of several Calgary arts groups met Thursday to form the Calgary Professional Arts Alliance, similar to the Edmonton Professional Arts Council. Yesterday's meeting passed a resolution "to support the autonomy of cultural and educational institutions in Alberta," formed committees to organize a rally in Calgary next Wednesday (paralleling a demonstration outside the Alberta legislature planned by the Edmonton group), and urged those present to begin a fax and letter campaign directed at their MLAs and new Alberta Premier Ralph Klein.

Last week, Deputy Premier Ken Kowalski outraged the arts and gay communities when — offended by reports of a one-hour show presented last November at the Banff Centre by the Vancouver lesbian group Kiss and Tell — he called on Advanced Education Minister Jack Ady to stop funding homosexual shows at government-funded institutions. (Kowalski is responsible for lotteries in the province, and has considerable input on funding decisions.)

Then Labour Minister Stockwell Day was quoted as saying that the government should stop using "taxpayer's dollars" to fund culture. Community Development Minister Dianne Mirosh, who is responsible for both culture and human rights, said there would be no more money for cultural funding.

Alberta Theatre Projects producing director Michael Dobbin had a large hand in the organization of the CPAA, and led the public protests this week. He and others in the arts community pointed out that cultural industry in Alberta employs more than 25,000 people; that arts grants in 1992 totalled only $42-million, or .3 per cent of the provincial budget, and almost all of that from lottery income; that the cultural sector in Alberta spends $358-million per year on wages and salaries alone, and that the arts add $75-million per year to the provincial economy.

Earlier this week, Day denied saying government funding for the arts should be stopped, but he also made it clear that he is going to be looking everywhere for ways to cut spending. "No group is safe," he said.

Kowalski said Wednesday that arts funding is "not on the block," and that the protesting arts groups should "just relax." He also accused Dobbin of "playing with a fantasy" and working toward "his own political agenda," and said that cultural-community protests are really intended to boost the arts groups' fund-raising efforts.

Dobbin rolled his eyes when asked yesterday what political agenda Kowalski might have in mind. "It bewilders me," Dobbin said. "I really don't have any idea what he's talking about."

Mirosh had already triggered charges of homophobia from Alberta's gay community for her opposition to enshrining legal protection for homosexuals in Alberta's human-rights legislation.

Then on Wednesday, a group of Tory MLAs defeated a motion in the Alberta legislature to congratulate Alberta-born singer k.d. lang for winning an American Music Award (the motion required unanimous approval to pass). Mirosh said the "no" votes were not due to Lang's lesbianism, but because the "meat stinks" anti-beef ad she made last year offended rural legislators.

Premier Ralph Klein was off meeting voters in rural Alberta this week, and is about to head for Quebec and Ontario to meet other provincial and federal politicians. As of yesterday, he had not commented on the series of furors created by his green cabinet ministers.

The cultural community's fears were not soothed by the latest report from Alberta Treasurer Jim Dinning, who says the province's deficit this year will be $2.76-billion, bringing the total debt to $15-billion. Klein has promised to balance the budget in the next four years.

Calgary Sunday Sun/31 January 1993

Picture of Controversy

Art forms focus
of heated debate

By Rick Bell

What is art? The question has inspired an ages-long debate without a definitive answer. And now, in Alberta, it's at the centre of a developing row between the government and arts groups over taxpayer funding via grants to artists. Reporter Rick Bell examines both sides of the controversy.

One man's meat is another man's poison.

Nowhere is this maxim truer than in the world of government arts grants — where a hunk of Alberta flank steak can become an artist's comment on the decay of society.

But the province's powerful arts community is now on a collision course with politicians seeking ways to cut the deficit-ridden budget.

In the last two weeks:

- Deputy premier Ken Kowalski attacked a tax-funded lesbian show in Banff as abhorrent and called on Advanced Education Minister Jack Ady to stop homosexual shows in provincially-funded galleries and theatres.

- Labor Minister Stockwell Day suggested there should be cuts in culture dollars.

- Culture Minister Dianne Mirosh said arts should be run like a business.

- Calgary's arts groups formed an alliance to protest the threat to funding.

As budget planners eye reduced spending, artists feel threatened by people they see as lowbrow, uninformed rednecks.

But it's not surprising there's a conflict — taxpayers paid for the following controversial projects:

- In 1990, the National Film Board gave 16 feminists $10,000 each to make five-minute films.

 One is a rap song about the joys of abortion and cross-dressing while another — We're Talking Vulva — features a dancing woman dressed as a vulva singing about sexual freedom.

- In 1991, the University of Calgary's Nickle Arts Museum presented The Castration of St. Paul — 30 photocopied snapshots of penises.

 Underneath each was the name of a religious figure, such as Jesus, God the Father, Noah and Moses.

- Last October, the museum featured the meat dress — 23 kg of prime Alberta beef stitched together.

- Last November, the Banff Centre for the Arts hosted

lesbian artists showing video-tapes of masturbation.

These are just a few examples — taxpayers across Canada pay for sculptures, paintings, films and theatre productions which almost nobody beyond the artists themselves really understand.

U of C art historian David Bershad said people don't like certain experimental art because it's meaningless.

"The public isn't stupid," said Bershad.

"They see much of modern art is really junk supported by holier-than-thou artists who think God whispers in their ear."

Bershad believes many new artists dismiss art resembling anything in the real world — such as a landscape or a portrait.

"These artists see art as a trick played on the public," he said.

Alberta College of Art president Robin Mayor is a painter who supports avant-garde art.

"I have to support it — they are people leading the public taste instead of following it," said Mayor.

But he doesn't expect politicians to understand what artists do.

"It's unfair to think a minister with no experience knows what is going on in contemporary culture," said Mayor.

Association of Alberta Taxpayers president Jason Kenney wants to see the public, not just artists, decide what gets funded.

"Bizarre, fringe groups get money for prancing about extolling their peculiar proclivities — sexual and otherwise," he said. "Let's have a panel of ordinary folks make the decisions."

Calgary sculptor Ken Craig disagrees. "Having the public judge the artists' work is like having accounts audited by someone who isn't an accountant — the result would be art with landscapes and animals," said Craig.

TOTALLING UP TALENT

	Alberta	Canada
TOTAL ARTISTS	6780	87,470
Painters, sculptors and related artists	590	9,200
Photographers and cameramen	925	11,380
Producers and directors	850	13,130
Musicians	1,605	14,765
Dancers and choreographers	130	1,485
Actors and actresses	180	3,655
Writers and editors	2,500	33,855

Source: Statistics Canada, 1986

GOVERNMENT MONEY SPENT ON ART

$ Canada Council (federal)
$107 million across Canada
($5.5 million in Alberta)

$ Alberta Foundation for the Arts (provincial)
$15.6 million

$ Calgary Region Arts Foundation (municipal)
$1.8 million
The Alberta Department of Culture and Multiculturalism spent $43 million last year on grants to libraries, museums, historical sites, multiculturalism and administration.

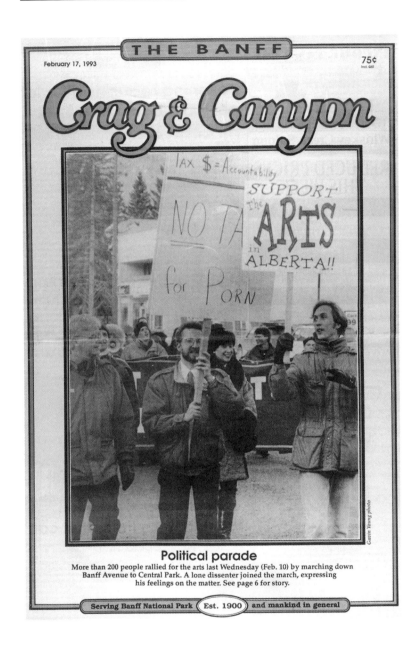

THE BANFF

February 17, 1993

75¢
Incl. GST

Crag & Canyon

Gazin Young photo

Political parade

More than 200 people rallied for the arts last Wednesday (Feb. 10) by marching down Banff Avenue to Central Park. A lone dissenter joined the march, expressing his feelings on the matter. See page 6 for story.

Serving Banff National Park (Est. 1900) and mankind in general

Banff Crag & Canyon / 17 February 1993

Hundreds rally for the arts in Banff

More than 200 vocal supporters of the arts marched down Banff Avenue Wednesday (Feb. 10) to show their commitment to culture in Alberta.

The rally is in response to recent comments made by provincial politicians that funding for the arts will be cut and support for specific exhibitions screened.

But at the same time as people were marching in Banff, the minister responsible for community development, Dianne Mirosh, spoke at the rally in Calgary, reconfirming the government's commitment to cut arts funding.

In Banff, the group marched from the high school down Banff Avenue to Central Park shouting slogans like "Where's the beef, it's in the arts," and "Don't be a bigot, dig it."

One placard read, "Culture includes gays and lesbians."

They were joined by a lone counter-protester carrying a placard stating opposition to funding for pornography.

At Central Park speakers touted the importance of freedom of expression and the importance of government support to the arts.

"I can't agree with the idea that quality should not be determined by the lowest common denominator," said Banff Mayor Leslie Taylor, who said she was not speaking on behalf of the Town, but from her own personal convictions.

A total of 174 people present at the rally signed a petition calling for the provincial government's support of the arts.

Parallélogramme Vol. 18 No. 4/1993

Kiss & Tell Spark Controversy in Alberta

A distorted and homophobic review in a right-wing magazine has sparked political controversy in Alberta about gay and lesbian programming at The Banff Centre for the Arts.

The Vancouver lesbian art collective Kiss & Tell (Persimmon Blackbridge, Lizard Jones, Susan Stewart) performed their multimedia work True Inversions at the Centre in November. The performance was concurrent with Much Sense: Erotics and Life, a group exhibition at the Walter Phillips Gallery, which included an installation by Kiss & Tell based on the performance and work by Robert Flack and Maureen Connor.

The review, written by Rick Bell, appeared in the December 7th issue of the Alberta Report. Subtitled "Banff hosts the latest in subsidized 'alienation' and lesbian porn," Bell's article uses a strange mixture of direct quotes from the performance and descriptive writing that completely distorts the work and the evening. It starts by describing a "cold, snowy night" in Banff — in fact, it wasn't snowing — and a crowd that was "mainly female of the military crewcut variety. Black leather jacket, black miniskirt, black tights or black fishnet stockings, and black army boots" — which describes, at most, five audience members — and goes on to misinterpret aspects of the performance. Despite the fact that the review obliviously announced "The audience loved it all, bestowing overwhelming applause at the end and two curtain calls," Bell concludes by drawing attention to the issue of such art receiving government subsidy: "As usual, the money for this free-admission spectacle came from the empty coffers of indebted governments."

The review sparked a number of public replies and discussions. Most notably, it caught the attention of Ken Kowalski, Alberta's Deputy Premier and man-in-charge of the provincial lottery money that funds cultural institutions, who told the Edmonton Sun, "Every once in a while they do some of these things that are God-awful in my humble opinion. This is the third [controversial show] I've had to deal with, this abhorrent lesbian show." He added that he had urged Advanced Education Minister Jack Ady to shut down homosexual shows at government-funded institutions.

Kowalski's comments sparked rebuttal from newspaper columnists in Calgary and Edmonton, most defending gay and lesbian programming at the Centre and pointing out that Kowalski was lashing out at an event he hadn't attended. In an article in the

Calgary Herald, Nancy Tousley surveyed reactions from the feminist and art communities to the spectre of censorship through funding cuts. In the article, Sandra Vida, coordinator of The New Gallery in Calgary, says, "We want to support the artists' right to present material that could be controversial. We don't want to handcuff them before they start." As well, the Edmonton-based gay and lesbian awareness group has announced plans to launch a complaint with the Alberta Human Rights Commission.

Sylvie Gilbert, curator of the exhibition, and Banff spokesperson Jon Bjorgum have appeared on radio and television discussing these issues. One phone-in program on CBC radio in Calgary asked the question, "Should lesbians and gays have rights?" Responses to the question were overwhelmingly positive.

The controversy about the Kiss & Tell show comes at a time when lesbian and gay issues are already at the forefront in Alberta. Dianne Mirosh, the new Minister of Community Development, a portfolio that includes culture, is under fire for her recent homophobic comments about protecting the rights of homosexuals.

—Lizard Jones,
Kiss & Tell Collective,
Vancouver, B.C.

Xtra! / 16 April 1993

Sex-obsessed censors

Alberta artists act up after queer culture attacked

Safe-sex appeal. Watch TV for these public service announcements, produced despite Alberta's Tories.

Story by David McIntosh

Queer culture has been publicly attacked in Alberta. The loose lips and looser thinking of Alberta's Conservative government have targeted gay and lesbian art in what has been called "the culture war."

The first shot was fired at the Banff Centre, which opened a group exhibit, Much Sense: Erotics and Life, in November '92. The show included psychedelic close-up photographs of male genitals by Rob Flack, as well as a performance by three Vancouver lesbian artists known collectively as Kiss and Tell.

Curator Sylvie Gilbert says that while Flack's work drew some negative response from the public (his photos of anuses suggest a male homosexual viewer), it was Kiss and Tell's True Inversions that drew a torrent of homophobia from Conservative officials and Reform party wannabes.

Under the heading "Banff hosts the latest in subsidized alienation and lesbian porn," the right-wing Alberta Report published a vicious attack in their Dec 7 issue. It described the Kiss and Tell performance as a "sacreligious obscenity" by "foul-mouthed, sex-obsessed lesbians." The Report also singled out Alberta's culture minister as being personally responsible for "paying women to masturbate in public" (the ministry is one of the Banff Centre's major funders).

Kevin Avram, of the Canadian Taxpayers Federation, stepped up efforts to discredit the Alberta government at the end of December. He launched a highly organized, month-long campaign against lesbians, the arts and government funding. Published in over 20 Western newspapers, Avram's article argued that "the real issue isn't censorship at all; it's who pays. If these people want to dress up with pig faces and show lewd movies, why should already overburdened taxpayers be forced to pay the bill?"

Not to be outdone, Alberta's newly appointed cabinet ministers attempted to ward off further attacks by pandering to homophobes. In mid-January, Deputy Premier Ken Kowalski demanded that the Banff Centre stop holding "god-awful" and "abhorrent" homosexual exhibitions. And Community Development and Culture Minister Dianne Mirosh made her now infamous statement that "gays and lesbians are having

more rights than anybody else." Mirosh was the cover girl of the January Alberta Report, which included an article claiming that homosexuals ingest several pounds of feces per year; are death traps and murderous pedophiles; and want to have sex with animals.

GALA (Gay and Lesbian Awareness) of Edmonton is considering legal action against the Alberta Report. Others are discussing the idea of a Colorado-style boycott of Alberta. In the meantime, although the Banff Centre prevented any direct interference with the Much Sense exhibition, funding threats and state sanctioned homophobia have had insidious effects.

A subsequent Banff Centre project at the end of January involved queer activist artists Noreen Stevens and Sheila Spence (aka Average Good Looks). These two, who have displayed their public art across Canada, proposed running a pro-queer message on TV monitors scattered throughout the Centre: "Touching you. Every day. Everywhere. Queer Culture." Though other artists have used the monitors for projects in the past, Banff administrators refused to allow Average Good Looks to do so.

The artists responded in February, plastering the Centre with posters of the banned message. They also lodged an official complaint, rejected by Banff Centre President Graeme McDonald. He continued to refuse to display their message.

At the same time, 10 Canadian and US video artists (nine queers, one queer-identified bisexual) were invited to the Centre to produce Second Decade, a project of public service announcements for television broadcast about AIDS, HIV and safe sex.

Second Decade's co-ordinator, Michael Balser, had had previous encounters with censorship when working on projects such as the cable program Toronto Living with Aids. His experience proved invaluable in negotiating the Banff Centre's efforts to undermine queer content (especially directed against lesbian themes). The Centre engaged in endless arguments, demands for script re-writes and other obstructive behaviour.

Fortunately, thanks to the artists' solidarity and determination, the PSAs produced provide a series of very hip and effective educational TV spots which will dazzle channel zappers of all sexual orientations. Their combination of ultra-cool image and urgent message are likely to be irresistible to national and local broadcasters such as the CBC, CityTV, CTV, Global and TVO.

Watch for them. And when you see them, remember that queer culture touches everyone, everyday, everywhere, safely.

Risque art risks loss of funding

By *Allyson Jeffs*
Herald Legislature Bureau

EDMONTON — Art galleries that display controversial material risk losing funding from the Alberta Foundation for the Arts, Community Development Minister Gary Mar said Tuesday.

Mar said a new formula for allocating funding from the foundation could see galleries that attract complaints or controversy having their funding pulled.

"It would be fair to say that funds for particular types of shows could not be supported by the AFA," he told reporters. He would not be more specific.

And while AFA executive director Clive Padfield said the changes apply only to galleries, Mar said theatre groups will be affected as well.

"To the extent that some plays offend the sensibilities of the community standards, there has been some suggestion that public funds should not be put forward to support such projects," he said.

Mar acknowledged he has not given any specific criteria.

"Pornography is a hard thing to define, but I know it when I see it," Mar said.

He denied it is censorship. He said arts groups can do whatever they want, but can't expect public money for their more risque productions.

Mar said the policy change was made in response to complaints about particular events. He couldn't say how many complaints had been received, or how many art shows or performances were involved, although it was "fewer than 10."

A spokesman for Mar's department noted two recent gallery shows have attracted controversy. They included last year's Kiss and Tell exhibition at the Walter J. Phillips Gallery at the Banff Centre — a show of work by lesbian artists exploring sexuality — and a forum at the New Gallery in Calgary called Diversity of Desire.

Lorne Taylor, MLA for Cypress-Medicine Hat, raised concerns about the New Gallery show several weeks ago because an advertisement said participants could experience gender altering, body piercing and tattooing.

In fact, most of the experiencing was done through computer simulations and slide presentations.

Taylor said he supports the funding changes "All we are doing is looking at a policy where projects that offend the sensibility of a majority of Albertans are not going to get funding, and it makes good sense," he said.

The changes will eliminate AFA funding for specific shows or per-

formances and reallocate that money to base funding for galleries. There will be no cut in the total amount of money allocated.

A total of $1.1 million is allocated to 22 public galleries in the province — $346,000 of that is for program grants. The money being spent on program grants will, in future, be rolled into the operating allocations.

Padfield said that the AFA board has wanted the funding changes for some time and that it does not consider the government to be cracking down on controversial shows.

The foundation is the government agency through which arts funding is allocated.

Padfield said program choices will continue to be in the hands of art gallery boards and their professional curatorial staff.

But Liberal MLA Bettie Hewes said the changes tread very close to censorship and amount to unnecessary political interference. "What they are doing is politicizing the business of the foundation and I don't like that," she said.

FOUNDATION FOR THE ARTS

Volunteer board which distributes lottery money to arts groups

The Alberta Foundation for the Arts answers to Community Development Minister Gary Mar.

It approves funding decisions while a paid staff led by newly appointed executive director Dr. Clive Padfield handles the day-to-day operations from an Edmonton office.

Chairman of the Board
- R.C. Jarvis (Edmonton)

Board Members
- Patricia Cavill (Calgary)
- Malcolm V. Edwards (Calgary)
- Sheila Edwards (Edmonton)
- Olive Green (Lethbridge)
- Bonnie Laycock (Red Deer)
- Lucille Partington (Sexsmith)
- Dale M. Simmons (Calgary)
- Carol A. Watamaniuk (St. Albert)

The National Gallery of Canada

(NGC) in Ottawa opened its glittering new building on Sussex Drive in May 1988. That summer I was plagued by nightmares about panic-stricken, horrified nuns hurling themselves off the balconies outside the video gallery in the contemporary Canadian art wing. They would glance up through the gallery window for one last, shocking look at the videotapes before crashing onto the cement floor thirty feet below. They were grey nuns, at least their habits were grey, and sometimes in my nightmares their billowing skirts would balloon with air and slow their descent, giving me just enough time to rush in and catch them. Others would just hit the ground and stick there, deflated grey blobs. I would wake up shaking with panic and confusion. How had I failed them?

SEX, ART AND CONTROVERSY IN CANADA'S PUBLIC MUSEUMS

Su Ditta

One of the attractions of the new building was the stunning re-creation of the Rideau Street Convent Chapel. The elaborately decorated and painstakingly restored installation featured the carefully preserved remains of the original chapel from the convent of Our Lady of the Sacred Heart. This had once been the home of the Sisters of Charity. The historic chapel was a famous local architectural attraction that had been secreted away in storage for some years. That, combined with the much anticipated opening of Moishe Safdie's grand new crystal art palace (the first real "home" ever built for the National Gallery's permanent collection), had attracted more than the usual number of summer visitors. And bus loads of nuns.

The contemporary Canadian art wing of the new museum featured an entire discrete gallery devoted to video art, the only institution in the country to do so. The NGC launched its permanent program of collecting and exhibiting in the media arts that summer,

73

and I had curated the inaugural exhibition, *New Works: Recent Acquisitions.* It was the launch of a biannual survey of new video by Canadian artists. This first survey was specifically designed to introduce audiences to the communities in which the artists worked, the range of theoretical and practical concerns that currently preoccupied them and the variety of subjects and aesthetic forms that captured their minds and imaginations. It was a kind of cross-Canada check-up on the state of the arts.

Needless to say, some of the work was about sex. Three of the tapes were about gay sexual identity, the construction of gay male desire and the inscription of the homoerotic in a variety of cultural environments. *Holy Joe* by Joe Sarahan (Vancouver), *Délivre-nous du mal* by Marc Paradis (Montreal), and *Chinese Characters* by Richard Fung (Toronto) were all works that had been exhibited previously in other venues and had received positive critical attention. All three artists were activists in their local artistic communities and played crucial roles in the cultural milieu, not only as individual producers, but as teachers, critics, editors, technicians, distributors and administrators. No contemporary Canadian video survey would have been complete without their work.

The exhibition of thirty-nine tapes from across Canada, my first exhibition as the National Gallery's new media arts curator, opened on 21 May 1988. The exhibition would prove to be the site of a tumultuous controversy later in the summer when the gallery was accused of exhibiting pornography. One complaint from a visitor, nearly three months after the show opened, catapulted the artists, the gallery and me into a high-profile battle about art and censorship. Media coverage of one person's opinion generated a crisis environment for the institution and tested our resolve to continue to exhibit work that we believed was important. It was a rough ride and those poor dreamtime nuns carried the burden of my anxiety and fear well into the fall of that year. My unconscious had adopted them as a symbol of my own unresolved crisis about whether I was being a good risk-taking curator or a bad trouble-causing curator.

As Brenda Cossman points out in her book, *Censorship and the Arts,*[1] western culture has a long and ignoble tradition of attempting to censure art practices that express ideas or sentiments that depart

from the mainstream conventions of the day. The ancient Greeks in Athens regularly tried to quiet writers whose philosophical and political musings were construed to be insulting to the gods. Similar persecutions were carried out by the religious reform movements of the sixteenth century, not to mention Anthony Comstock's turn-of-the-century Christian fundamentalist crusaders and Pope Paul X's attacks on Michelangelo's *Last Judgment* in the 1930s. The end of the twentieth century in North America, for all its sexual and political liberation, has been marked by the Ontario Censor Board's assault on the work of film and video artists in the eighties and U.S. Senator Jesse Helms' recent attempts to stop funding to the National Endowment for the Arts (and exercise congressional control over public funding of "offensive" art). Despite the official separation of church and state, the religious right and elected officials have frequently joined forces in explicit efforts to regulate and circumscribe artists' thinking about sex and their imaginative rendering of their ideas in pictures, performance or text. It has always been hard to talk about sex in public, but artists have always been compelled to do so and somebody is always trying to stop them.

If sex has historically been dangerous ground for artists, it has been a minefield for the public institutions charged with the responsibility of collecting and exhibiting their work. Although these public galleries exist today within a secular world, the fringes of the religious community frequently lead the battle to throttle the right of public institutions to explore issues related to sexuality, and attempt to intimidate exhibitors and demonize artists who dare to take risks or approach the transgressive. The state interferes where it can, curiously restrained by the rigours of the law. However, the most intimidating force at work, shutting down the discussion of sex in the arts in the past decade, may well be the budget-slashing politician or policy maker, riding a wave of enthusiasm conjured up by a scornful and muckraking press. Cultural leaders need thick skins, crystal-clear principles, courage and an unwavering determination to withstand the onslaught of threats and intimidation that accompany a controversy about sex and art. A sense of humour helps.

The ideological arguments developed to support attempts to stifle debate and suppress frequently marginalized points of view are remarkably flexible, transforming infinitely to suit the political tenor of the times. Artists who have pushed the boundaries of critical thinking about sexuality have frequently been denounced as degenerate, depraved, blasphemous and indecent, and their work labelled vulgar, immoral, obscene or just plain not-art. Penalties have ranged from death and imprisonment to fines and the altering, confiscation and destruction of their work.

In recent years, religious and other moralizing critics have drawn on contemporary feminist debates about pornography to support their positions, casting artists and museums as part and parcel of a threat to the safety of women and children, not to mention the general health of civil society. Currently, though, it is vogue for politicians and business lobbyists to distance themselves from the spectre of censorship (which is, after all, a tool of big government), and to hide behind the neoconservative rhetoric of "simply" ensuring that taxpayers' dollars are used to support only art that is popular with the public. The most recent controversies have arisen not around art in churches, privately funded museums or commercial galleries, but in public institutions supported with public funds provided by tax dollars.

It is this critical and contested idea of "public" that is central to debates about what government-funded institutions should or should not exhibit. Museums and galleries are traditionally held to have a public trust. They are charged with the task of preserving our cultural heritage and providing access to that heritage. They are guardians, preservers, caretakers and, more critically, researchers, interpreters, educators and information providers. The foundation of a public trust rests on an institution's independence and its ability to make freely informed decisions about what to collect and exhibit on behalf of the public. A museum is expected to provide a balanced view and yet be visionary, to look into the future with a critical imagination and determine what is acute in our present and what must be preserved, so that we can make sense of both the past and the present in our future. An institution with a mandate in the

contemporary arts has a unique public trust. It must provide knowledge about the contemporary world and a critical discourse on contemporary art practice. It should be a place for inquiring minds.

An institution's professional staff must constantly position itself ahead of current conventions and established canons and place its thinking before the public for judgement. That "public" is a complex construction and involves a negotiated relationship with a wide variety of communities and points of view. As a meeting place of thought and practice, a museum constantly reinvents reality and makes those inventions available to the public for observation, discussion and debate. It creates a dialogue on experience. When access is denied and the dialogue is circumscribed, the public worth of the institution and its value to public life are diminished.

When a controversy around sex arises in a public museum or gallery, the institution has to test its understanding of public trust. Will the public be the government of the day? Its membership? The arts community, a religious lobby, a taxpayers group? Will the institution be able to make the distinction between intellectual conflict about the significance and meaning of a work of art or the politics of a historical vision being presented and an attempt to silence debate and "dumb down" the museum? Will it turn a blind eye to arguments about cultural appropriation and the bias of its collections and yet capitulate when a newspaper columnist says a work is obscene? Institutional bias abounds and "culture" is constantly edited, sometimes even erased, in the exhibition process. But the construction of the contemporary art gallery as forum rather than temple is the fundamental starting place.

An understanding of the value of public debate and its relationship to operating in the public interest is central to the principles and beliefs that influence public galleries and museums when they are faced with choices about programming potentially controversial work. It may be easier and safer to avoid work that irritates, offends or outrages some members of the public, but this is not necessarily in the public interest. A wide variety of fears can overwhelm public institutions whose core values should lead them on a spirited path of intellectual exploration, which includes and even welcomes

controversy. If fear does not stop them from programming controversial work about sex (or if the work somehow slips unnoticed through the system in the hands of an earnest curator), a lack of will, political finesse and media smarts can all combine to bring the exhibition, the institution's principles and, ultimately, its good name and reputation tumbling down.

What is it that people working within the institution are afraid of? The most immediate and understandable fear is that of the law, of being prosecuted under the Criminal Code for contravening the obscenities legislation (including the new child pornography provisions). But no public museum in Canada has ever been prosecuted for obscenity, and the state has been generally unsuccessful in convicting individual artists or private art gallery owners. Commercial Toronto gallery owner Dorothy Cameron was prosecuted and convicted on seven counts of obscenity in 1966 for exhibiting Robert Markle's paintings of nude (heterosexual) lovers, among other works, in an exhibition called *Eros '65*. She was fined three hundred and fifty dollars (fifty dollars for each work), but she never went to jail. Similar charges were dropped against Av Isaacs for exhibiting sculptor Mark Prent's work in 1972. Child pornography charges were dropped against Toronto artist Eli Langer in 1993 and his paintings were found "innocent" in a forfeiture hearing in 1995.[2]

Nevertheless, the fear of a costly and demanding court case, even one with a potentially successful ending, hovers like a dark cloud over all but the most rigorous and adventurous curators. Institutions may try to "second guess the official censors," as Brenda Cossman puts it, by self-censoring to avoid any public scrutiny or police action and prosecution. "Much of the censorship of the visual arts in Canada is not directly at the hands of the law, but rather at the hands of curators, funders and political officials."[3]

Self-censorship, as Cossman points out, may be the most dangerous kind of censorship because it takes place behind closed doors and there is no public accountability for the institution's actions. Fearful and overwhelmed by their sense of vulnerability to prosecution and public reaction, museums and galleries may retreat and limit themselves at the beginning of the curatorial process to

the safest and most conventional ground, resulting in a very private chill. It is a quiet kind of censorship.

Those whose best instincts are to resist the temptation to simply avoid the anticipated displeasure of police, courts and the consequences of the law by playing it safe frequently face an intimidating wall of other impediments, both real and imagined. Curating an exhibition that involves sexually explicit material, no matter how intellectually rigorous or historically important, also means confronting a barrage of opportunistic politicians, religious extremists, special-interest-group lobbyists and a press that creates, as much as it reports on, controversy. The spectre of public outrage and loss of funding are potent and popular threats, frequently at work behind the scenes to bully and intimidate public museums. Public shaming and ridicule, not only for being perverse and immoral, but also for abusing "taxpayers'" dollars have become the weapons of choice in the battle to censor the arts. It works. Museums panic about losing grants and curators climbing a rising career path may be loath to risk being labelled troublemakers who provoke public outrage and play loosely with ideas about artistic freedom at the taxpayers' expense.

What we forget, though, is that while frayed nerves and nightmares from the overwhelming pressure of effectively managing a controversial exhibit take an enormous toll on all parties involved, the galleries and museums in Canada that have stuck by their artists and curators have not suffered damaging blows to their budgets, nor have they lost membership or audiences. In fact, they have enjoyed an enhanced reputation in the artistic community and increased attendance.

Unfortunately, what does get lost or watered down in this pressure cooker of anxiety is a public institution's responsibility to pursue ideas, research, investigation and analysis of contemporary art practice at arm's length from any of the interests that may seek to quiet them. Like libraries and universities, these institutions are part of a complex network of social organization that is fundamental to the health of a democratic society and the diversity of voices that keeps it democratic. Capitulating to self-censorship early in the curatorial

process or retreating from commitments to controversial works and exhibitions ultimately threatens the relevance of these institutions.

Some institutions, such as the Walter Phillips Gallery in Banff, have refused to be daunted by government harassment, threats of funding cuts or veiled warnings in the press to close exhibitions, remove works of art from display and restrict their programming. Others have given in, sometimes before anything actually happens.

Controversy around sex and art in Canada does not only happen in the province of Alberta, and it is not only living under the Klein government that makes talking about sex in a public gallery difficult. It can happen anytime, anywhere and it does. This essay provides some context for the experience at the Banff Centre for the Arts, where the controversy arose over the exhibition *Much Sense: Erotics and Life* at the Walter Phillips Gallery. It locates the distinctive turning or crisis points in the emergence of a controversy as they develop in different moments of the exhibition process: just before the show opens (when internal anxiety is in full force), after the media has transformed the reception of the exhibition (establishing a media-induced frenzy) and later, when threats of lawsuits or funding cuts emerge. It examines four cases of Canadian public galleries and museums that responded in different ways to including work about sexuality in an exhibition or that presented shows containing sexually explicit material. Whose worst nightmares came true?

These four public institutions all have a serious commitment to contemporary art; all have faced challenges to their artistic decisions in the past decade. In each case their struggles received a great deal of public attention. None had a direct confrontation with the police or the courts or were criminally prosecuted. All of them were forced to face the spectre of their own fears, and to confront threats, actual or anticipated, to their reputations and to their financial survival. These battles were carried out largely in the press, where "public outrage" was defined by reporters' opinions and speculation, the posturing of politicians and a minority of letters to the editor. As these case studies illustrate, the institutions that gave in to their fears were as besieged as those that stood their ground but, ulti-

mately, those that walked away from their commitment to contemporary artists and their work may have paid a much higher price.

In the course of my examination of these cases, one common element became very clear: the greatest difficulties arose around the exhibition of work that explores issues of gay and lesbian sexual experience and identity. Much has been written by artists about the innate tendency of museums to objectify, rarefy and appropriate the works they collect and exhibit. Cultural critics have deplored the institutional process of validating certain art and excluding other kinds of work to establish an approved artistic canon. In a twisted way it is this power to validate certain images and practices that gets museums into trouble when they focus on gay and lesbian work. This is a reflection of human experience that some people would prefer to see stay underground, forever marginalized and excluded from the mainstream. It is the legitimacy bestowed by the museum that becomes objectionable.

All of the cases involve the exhibition of contemporary video or photography, whose realist and popular culture associations distinguish them from the historically laundered representations depicted in older painting and sculpture.

▮ PAUL WONG AND THE VANCOUVER ART GALLERY

Paul Wong got the news in the basement of the Vancouver Art Gallery (VAG) at 2 p.m. on 21 February 1984. He was dry mounting the photo narrative that was to accompany the exhibition of his video installation *Confused: Sexual Views.* It was Wong's most recent work, and it was scheduled to open in three days to inaugurate the video space in the VAG's new home in a monumental downtown courthouse, which had recently undergone extensive and expensive renovations to complement its new role as an art museum. Curator Joanne Birnie-Danzker came to tell Wong that she had just finished a long and contentious meeting with the VAG's director, Luke Rombout. After screening three and a half of the nine hours of tape in the piece, and despite the objections of his curator, Rombout was considering cancelling Wong's show.

At 5 p.m. that day, the artist met with Rombout, who told Wong he was worried his installation might offend some gallery members. Rombout said he could not defend the piece as a work of art and, in his opinion, it had no relationship to the visual arts. Fearing damage to the VAG's public profile, Rombout informed Wong his show was cancelled. It was a decision that unleashed an unprecedented storm of controversy.

The next day Wong initiated legal action for breach of contract against the gallery and Rombout. He also served a Notice of Motion seeking a mandatory court injunction, requiring the gallery to proceed with the exhibition.

Some of Wong's earlier productions had been exhibited previously at the gallery in a group show, and his oeuvre was well known to the VAG's curatorial staff. Birnie-Danzker had seen *Confused: Interviews* (a related performance work and short tape) at Harbourfront in Toronto earlier in 1983. It was produced by Wong and collaborating artists Gary Bourgeois, Gina Daniels and Jeannette Rheinhardt, and had been financed with a grant from the Canada Council. Wong had sent a proposal to the VAG in the summer of 1983 outlining his idea for a second phase of this particular project, to be called *Confused: Sexual Views,* but the VAG had declined his proposal to initiate it on site in its new headquarters. However, seeing phase one of the project in Toronto had apparently changed Birnie-Danzker's opinion and, at her invitation, Wong set to work in the early winter of 1983 designing and producing his installation. The VAG agreed to pay him a fee of one thousand dollars.

The complex, site-specific installation included four monitors mounted in an X-shaped wooden structure. Three of the monitors played the same tape; a fourth featured a random sampling of selections from the entire nine hours of tape. Viewers would see twenty-seven intimate, straight-on, head-and-shoulder shots of different individuals and couples talking about sex, their opinions on sex, pornography and religion, and their wide-ranging sexual fantasies and experiences. Nobody was having sex, at least not on the screen. The subjects were responding to the questions of an off-camera interviewer whose voice had been edited out. They appeared to be and, in fact, were real people (not actors), with a

variety of attitudes and theories about sex and different sexual practices. Frank discussion, unmediated by experts or dogma. But that is all it was—talk. Talk about a taboo in a format that carefully and cleverly challenged the boundaries of traditional documentary and placed the testimonials in a constantly changing frame. The tape sequence was to be changed regularly, adding another dimension to Wong's themes of multiplicity and choice. Deconstructing the linear structure and hegemonic assumptions of both the mass media and orthodox documentary, Wong's work made perfect sense within the context of Vancouver's own video-art history and the blossoming debates on the international cultural theory scene about gender, sexual identity and representation.

During the course of exhibit planning, Wong and Birnie-Danzker had had numerous conversations about the nature of the work and had agreed that admission to the video gallery would be restricted to persons over eighteen years of age. It was an extraordinary move for an institution to make of its own accord without the pressure of any specific legal requirements, but nevertheless one that indicated the VAG was well aware of the content of the work. Both parties seemed to agree that Wong's installation might prove problematic for some audiences, and they were willing to take measures that demonstrated sensitivity to any potential concerns, while ensuring the integrity of the artist's work by exhibiting it in its entirety.

In December 1983, Birnie-Danzker sent Rombout a memo that stated: "If by some chance, you don't want this show, you could stop the publicity from going ahead."[4] However, the publicity did go ahead. On 6 February, a press release announcing the exhibition was issued. The February/March VAG calendar of events, mailed to twenty thousand members, included a photograph of Wong and his collaborators and described the multi-monitor audio-visual photo installation as "provocative, entertaining and humorous." It also included the cautionary note: "Because the subject matter may be offensive to some people, entry is restricted to those eighteen years and over."

After viewing all twenty-seven interviews in the videotapes on 16 February, the curator once again advised Rombout of the contents of the show in a memo dated 17 February: "We all recognize ...

that unless it is handled very carefully there could be tremendous controversy about the show."[5]

The memo goes on to say that the gallery's best bet for coming out "unscathed" was to take "a strong, clear stand in defence of the work," and, to that end, Birnie-Danzker prepared an eloquent curatorial statement about the installation. Concerned that the piece contained more coarse language than she had anticipated, she outlined a number of possibilities for warning signs to accompany the installation. There was a thoughtful plan in place, so what made Luke Rombout change his mind at the last minute?

Throughout the trial, much was made of Rombout's shock and dismay over the piece and his right as the institution's chief executive officer to reject any work that he felt was not suitable. The British Columbia Supreme Court judge who heard the case found in his ruling that there was no malice or animosity on Rombout's part when he decided to cancel the show, because Rombout's decision was based on his honest conviction that the work might offend the public and alienate some of the VAG's newly acquired members. While Rombout may have been honestly afraid, it is hard to believe he found the work impossible to defend as art or that he was not aware of its content and was surprised by the final results. Radical, hard-edged documentary has deep roots within the Vancouver media arts community and is an integral part of that city's art history. Rombout had been given plenty of warning about *Confused: Sexual Views* and had let the production and planning for the opening proceed.

In his court testimony, Rombout recalled a photograph in the VAG's opening exhibition by local artist Chris Gallagher, which featured a Santa Claus carrying a severed reindeer head. It had drawn letters and calls of complaint from the public. Media coverage had been intense and Rombout had been under enormous pressure. Once burned, twice shy? Philip Palmer, writing in *CARFAC News,* (Canadian Artists Representation/Front des artistes canadiens) suggests that the VAG management, including its director, "lacked confidence" and, overwhelmed by the media's ability to generate controversy about a work of art out of context, was not quite up to

the task of running such a big institution with a newly established high profile.[6]

Was there truth in the unsubstantiated rumours circulating that Rombout had been quietly warned to withdraw the Wong tapes if he wanted to secure the additional funding needed to complete the VAG's renovations? Who was calling the shots? Rombout, the gallery's membership, the recently elected right-wing provincial government, corporate sponsors, an aggressive media or an ephemeral, offended public that had yet to see the work and pronounce judgement?

In addition to initiating the three-pronged court action, Wong worked with artists in the community to develop a media campaign and had press kits ready when the injunction was heard in a packed courtroom two days after the exhibition was cancelled. A nearby community college screened the tapes for the public. Professional arts organizations across the country wrote to the gallery and to the press condemning the VAG. Artists organized a "wailing wall" and demonstrated outside the gallery premises; still others called for a boycott.

On 22 March 1984, the 53rd Annual General Meeting of the Vancouver Art Gallery was attended by more than two hundred outraged members, who presented a petition signed by almost four hundred people, deploring Rombout's action and demanding that the VAG apologize to Wong and "redress" the situation. Speakers from the floor denounced the decision to cancel the installation as an action that "demeans and patronizes all new members" and contended that the affair had had serious consequences, including the creation of "a rift between the VAG and our artistic community ... damage to the gallery's reputation, and the lowering of staff morale."[7] Only a few voices spoke in support of Rombout. Motions demanding the gallery apologize to Wong and establish a committee to investigate the whole affair were passed by an overwhelming majority of the voting members. The motions were later sidelined on technical grounds and were ignored by the board of directors. No apology or investigation was forthcoming in spite of the members' demands.

Headlines about the "sex artist" and his "offensive videos" marked the field day the mainstream press had reporting on the case. However, the editorial pages were articulate in their defence of Wong and their criticism of Rombout and the gallery.

The *Vancouver Sun* commented:

VAG director Luke Rombout has decided Vancouver isn't grown up enough to be allowed to see a video exhibit including explicit discussions of sexuality.... Mr. Rombout is playing it safe. He doesn't want to offend any more of the VAG's thousands of new members, some of whom were scandalized by a few items in the opening exhibit in the new gallery. Such a pity. The Gallery had the opportunity to be a bit daring, to challenge the local art community, to be innovative and different. Instead a signal has been sent out that art must conform with the most straightlaced notions of morality among the Gallery's patrons in order to get into the VAG. Vancouver will be the poorer for that.[8]

The *Province* editorialized:

The people who run the Vancouver Art Gallery may have been damned if they had run the controversial Paul Wong video exhibit, *Confused: Sexual Views*—just as they are being damned for not running it. But what's most disturbing about the affair is that they seem confused themselves about the role of the gallery as it sets a course in the big leagues of art.... Since the Wong work won't be exhibited the public won't be able to judge for itself whether it is art or not, or whether it is offensive. Rombout's unwillingness to risk offending people is the real problem with his decision. It conjures an image of the new Vancouver gallery as a "safe," conservative institution where there will be no place for new or experimental art. It suggests that the gallery may be wrapped in a cocoon protecting it from public controversy. However many people might have supported Rombout's judgement on the Wong work is immaterial. If the Gallery is not prepared to risk controversy and even disapproval, its contribution to the community will be devalued.[9]

In Vancouver's case, talk about sex could be viewed either as something taboo or as part of an international art discourse that moved the city into line with intellectual debate in other urban centres. Public debates about the merits of a particular work of art may be seen as something to be avoided at all costs or conversely as an engaging part of life in a cosmopolitan metropolis.

Both the *Vancouver Sun* and the *Province* were firm in their commitment to the idea that a good museum could and, in fact should take on controversy whether it wins the ensuing battle of popular opinion or not. Both these editors saw an essential role for serious, professional arts institutions to present projects that are not safe, and to be willing and able, when the art demands it, to push the boundaries of what has been established as acceptable in the public sphere. Media coverage may make it more tiresome and demanding for artists, curators, directors and boards to carry out this mandate, but it was clearly seen by the newspaper editors as an obligation on their part to do so. Placid museums shirk their public responsibilities.

The Vancouver arts community was well organized and prepared to play a strong role in any media debate that took place. In addition to being prepared with press kits and articulate spokespeople, Wong supporters rallied the alternative press and provided it with interviews, gossip columns and letters. National arts publications such as *Parallélogramme* and *CARFAC News* published major articles on the case that all shed a poor light on the gallery and Rombout, attacking the institution for being cowardly and acting in bad faith. John Bentley Mays gave Wong's work the serious attention it deserved in an almost-full-page article in the *Globe and Mail* just before the work premièred in Toronto at the Funnel Experimental Film Theatre in March 1984.

While some of the alternative press discussion concentrated on the legal and formal problems revealed by the incident and focused on proposals for various bureaucratic solutions (the need for better contracts, advance planning of exhibitions, et cetera), other writers attacked the key issues at stake. Their analysis still holds its insightful, critical edge today.

Elspeth Sage, writing in *Parallélogramme*,[10] linked the situation to the status of the artist in Canadian society and pointed out where

the balance of power lay in most public institutions. She suggested that when a museum cancels an exhibition after the normal curatorial process, it retreats from an ethical commitment to bring art to the public, a commitment that should be at the core of its mandate. In the Wong case, there were any number of "experts" who believed the work had extraordinary artistic merit. Rombout's decision, she wrote, reflected the unrestrained exercise of "personal taste and prejudice," based on his own concerns about sexuality as a subject just too hot to handle. The VAG, she argued, had no way of knowing what would cause offence or who might be offended in such a situation. The VAG's board did not feel itself accountable to its artists, its curators or, it seems, to its voting members.

In an article published in *Video Guide,* curator and video artist Sara Diamond pointed out that the decision was essentially a political one, "retaining the sphere of sexual experience as a private terrain, inappropriate for exploration within a public space." For Diamond this was not a simple issue of personal freedom of expression, but one that was linked to the museum's function as a site for research and investigation, a place that could and should be encouraging the exploration of alternatives to the imaging of the erotic within the current culture, rather than striking a "major blow to developing a new understanding of sexual representation," and sending a message to artists that they must not "criticize the dominant imaging of sexuality in this culture," or refer to "alternative sexual experience."[11]

In the end, though, Wong was not successful in gaining "injunctive relief" that is, the exhibition stayed cancelled. When the case against Rombout and the VAG finally came to court, two years later, the judge ruled in favour of the gallery's director and the institution, claiming there had been no breach of contract. But the moral victory clearly went to Wong; the museum received more unfavourable public attention than anyone could have imagined. The artist received his thousand-dollar fee, the work was purchased and later exhibited by the National Gallery of Canada, and Wong went on to win the Bell Canada Prize (awarded by the Canada Council) for outstanding achievement in Canadian video art.

The VAG had a legal bill estimated at well over a hundred thousand dollars and has spent years trying to regain the trust and confidence of the local arts community. In October 1984 (just seven months after the exhibition was cancelled), Rombout resigned and moved to Montreal to work as a consultant.

▆▆▆ EVERGON AND THE MENDEL ART GALLERY

It is difficult to determine what some people objected to in the Evergon show. Male nudity? Sexuality? Homosexuality? Religious imagery accompanied by homosexual imagery? A distaste for pleasure for its own sake? Or does a knee jerk reaction against sexual imagery of any kind simply mask a deeper abhorrence for art, for anything that questions mainstream values, that challenges the acceptable facade of "a wholesome family oriented" culture (ominously overshadowed by the realities of sexual and physical abuse, misogyny and incest).[12]

In late November 1989, just after the opening of *Evergon: 1971–1987* at the Mendel Art Gallery in Saskatoon, Saskatchewan, gallery board chairman Lorne Pendleton and director Linda Milrod received a letter from Terrence Goudy of the Society of Christian Counselling Services. The letter requested that warning signs be posted and children be prohibited from viewing the Evergon exhibition; it also itemized the nine works of art that Goudy found offensive. His concern rested on the show's homosexual content and his opinion that the artist's work would "promote the viability-attractiveness of a sexual orientation, which is contradictory to the sexual preferences of the majority of the citizens of the province."[13] He copied his letter to the Saskatoon City Council, pointing out that tax dollars were used to subsidize the Mendel: "Can this kind of insensitive use of public funds jeopardize in any way our city's financial commitment? If not, to whom is the gallery accountable?"[14]

One letter. One letter that kicked off months of debate at City Council, board resignations, a full-scale review of the museum's

| EVERGON, *Terry and Big Muffin*
(1976) detail

exhibition policy and more than fifty newspaper reports and letters to the editor in the local press, along with national media coverage of the issue. This exhibition of work by Evergon, a renowned Canadian photographer, had been organized by the Canadian Museum of Contemporary Photography (CMCP), an affiliate museum of the National Gallery of Canada in Ottawa. It included a selection of photographs and photocopy collages produced by the artist during a sixteen-year period. Organized by veteran CMCP curator Martha Hanna, the show was in high demand and toured to museums and galleries in thirteen cities across Canada and in Europe. The only controversy arose in Saskatoon.

Evergon's work had received a great deal of critical acclaim, and he was the recipient of the 1989 Petro-Canada Award for outstanding achievement in new media. He is considered a technical genius, and his elaborately constructed pieces were alluring and sensual, replete with art-historical references, often witty and wry, and richly imbued with multiple meanings and open to many readings. Opulent settings and exotic costumes shaped the context for Evergon's explorations of the play of erotic desire in religion, theatre, opera and painting. The images, whether photographic or photocopied, were complex and suggested their own discrete narratives. Some of the narratives were about sexual desire and the representation of the erotic.

The Mendel took the matter seriously as press coverage of Goudy's letter intensified but refused to back down in their defence of the artist and the exhibit. The gallery would not agree to post warning signs (readily available exhibition brochures were clear about the show's content). What seemed a simple request for warning signs from Goudy was clearly perceived by the gallery's management as the dangerous "thin edge of the wedge." The institution's professional staff and, it appears, the majority of the board were astute in their analysis of the larger political and ethical questions at stake. Posting warning signs to placate City Hall suggested an alarming change in the gallery's relationship to the public, asking the institution to assume responsibility for judging what the public needed protection from. By linking his request to accountability for municipal funding, Goudy challenged the traditional arm's-length relationship between the museum and the local government, proposing an unprecedented intrusion into the gallery's exhibition policy. The Mendel, run as a municipal corporation with an appointed board, received eight hundred thousand dollars a year, about half its budget, from the city, and Milrod rightly feared the possibility of "censorship by funding."[15]

Public response to the exhibition from those who had actually seen the work ran a predictable gamut. One mother from Winnipeg said she found the collection "bizarre" and suggested that a disclaimer sign at the entrance might prepare visitors for what was on the walls. But she remained unconcerned as her kids ran from one work to another, recounted *Saskatoon Star Phoenix* reporter Terry Craig after interviewing visitors in the gallery on a Saturday afternoon. Craig reported that audience members from Edmonton and Toronto described Evergon's work as "stimulating and beautiful;" they said no disclaimer was necessary and commented that the gallery's freedom of expression was "extra important."[16]

The Mendel's board and administration remained firm in its commitment to the work and clear about the broader picture: "The Gallery wants to have a balance in what it presents. It strives to give different views," said Chairman Pendleton. "It would be very easy to

eliminate controversial pieces; art throughout time engages in this discussion."[17]

City Council agreed with the Mendel and on 11 December 1989 simply "received" Goudy's letter, and took no further action. The *Star Phoenix* supported Council's decision:

> Saskatoon's art community was well served this week by a City Council that had the wisdom to know when to do nothing at all.... To have done otherwise would have invoked the spectre of censorship, and might well have undermined the authority of those who have made the Mendel the reputable gallery that it is.

The newspaper went on to say that the nature of the exhibit was well advertised and that parents could steer their children away from the provocative work if they thought it inappropriate. It found the reluctance of the Mendel's administration to post warning signs understandable: "To do so would be to make a presumptuous judgment on the visitor's behalf.... The Gallery's reputation speaks for itself. The Mendel exhibits art, not pornography. And the gallery's administration is best equipped to make the distinction."[18]

But the controversy did not end there. A letter to City Council from local artist Honor Kever congratulating the Mendel and City Council on their strong stance kicked off another round of debate. This time it was Mark Thompson, alderman and member of the Mendel's board, who suggested that the public should be warned that some works on display at the Mendel Art Gallery might be offensive. Comments from another alderman, Morris Cherneskey, revealed that the Mendel's worst fears about the seriousness of the threat they were facing were well founded. "The city shouldn't be funding what is considered offensive," he said. "I want to warn that we don't intend to fund that sort of thing."[19] There was another twist to the conflict. Mark Thompson was planning to run for mayor in the coming fall election. A devoted religious leader and an ambitious politician had set their sights on a high-profile public issue and the Mendel was under siege.

The council initially told Thompson to take his suggestions back to the Mendel's board, but in January he resigned from the board,

disappointed in certain aspects of the gallery's operations. He wanted the Mendel to cut back its hours and charge admission. He also made it clear that "what is needed is some type of warning system for displays which may be considered distasteful by some members of the public."[20] The majority of the gallery's board did not agree.

Streams of letters to the press continued over the next few months, and vitriolic debate about warning signs and "filth and pornography" continued at City Council. There were calls for Linda Milrod to resign because she was not acting like a good civil servant. The gallery's board was asked to appear before the city's Legislation and Finance Committee in March 1990. Its report, tabled in April, expressed the committee's point of view that in addition to being open to public criticism, the gallery should consider a warning system and that the "responsibility for Art exhibitions should lie with the gallery board and not with the curator."[21]

This was enough to start artists in the community organizing. More than one hundred artists attended a public meeting called to rally support for the Mendel and Evergon. The group established an action committee and issued press statements praising the gallery's professionalism and the merit of Evergon's work. Senior artists from a number of artistic disciplines made presentations to City Council, urging members to preserve Saskatoon's arm's-length tradition in the arts.[22]

It was a great tug of war around public funding for the arts, with some city politicians declaring their devotion to taxpayers' rights and claiming that they were not interested in censorship but in fair warning and accountability. Others stood firm in their belief that the Mendel was a credible professional institution with a strong track record, which should have the freedom to determine its own programming. The subtext of the debate was, of course, the "disgusting" nature of a gay man's work and the attempt by public officials to make it invisible. Would the city's commitment to its arm's-length policy hold up in that atmosphere?

In a *Globe and Mail* report on the crisis in March of that year, the forty-six exquisite works in the Evergon collection were reduced to "depictions of male and female figures tied with ropes and, in one

case, bound women in plastic bags."[23] But the gallery was receiving positive letters of support that outnumbered negative ones ten to one, and director Milrod affirmed the gallery's mandate and principles. "It is not our job to judge what the community needs protection from," she said. "It is our job to allow a free exchange of ideas about sometimes controversial matters."[24] Milrod was clear that the implications of this debate went well beyond the Mendel.

The exhibition stayed open until its scheduled close without any warning signs and attendance went up dramatically. The show completed a successful national, and then international, tour without further incident. Newspaper editorials remained encouraging and lauded the Mendel's professional reputation, good record and community appeal.

After months and months of controversy, even City Council seemed to grow tired of the debate and there was little enthusiasm when later that summer Mark Thompson tabled a report by a review committee suggesting, among other things, that the Mendel's grant be cut by one hundred thousand dollars in 1991 and further reduced by an additional hundred thousand in 1992.

In an interview, former Mendel curator Bruce Grenville theorized that Christian Services counsellor Terrence Goudy was a serious and concerned person, but that the issue snowballed in the media spotlight (there was a television debate and seemingly endless radio talk shows and interviews), and became an unanticipated but strategic political springboard for Thompson.[25] Thompson continuously fanned the flames of the controversy, although his opinions were in the minority on both the Mendel's board and on City Council. But Evergon had roots in the Saskatoon community and the Mendel was a well-respected local institution. The arts community demonstrated its support and the gallery maintained its stand, despite the machinations of municipal officials hoping for some easy political mileage.

The gallery's exhibition policy was due for a regularly scheduled review, according to Grenville, by this time a curator at the Edmonton Art Gallery, but there were no significant changes as a result of the review. The Mendel's grant from the city was reduced by twenty-eight thousand dollars in 1991 in a round of budget cuts,

but in the deficit fighting climate, several other groups and organizations were cut even more deeply than the Mendel. There was, Grenville says, a terrible exhaustion for the Mendel's staff and board, something of a "chill" from weariness, if nothing else.[26]

The Mendel did proceed a few years later in 1995 with the controversial Richard Attila Lukacs exhibition, despite sensational pre-opening press coverage. However, some in the community worry that the Mendel is now more cautious and sensitive to public scrutiny, less willing to take risks, the board watching programming more closely than in the past.

Mark Thompson lost his bid for mayor.

▮▮▮▮ MARC PARADIS AND THE MUSÉE DU QUÉBEC

Marc Paradis got the call the day before his work was scheduled to be shown. His video trilogy, *Délivre-nous du mal, L'incident Jones,* and *Lettre à un amant* was to be featured along with thirteen other tapes in the video portion of *Un archipel de désir : les artistes québécois et la scène internationale,* the contemporary art exhibition curated by Louise Déry for the opening of the newly renovated and expanded Musée du Québec in May 1991. Apparently the screening was not going to happen the next night as planned. It never happened at all.

Déry had worked on the plans and preparation for the show for some time. It was a large undertaking that included some forty works by contemporary Quebec artists, all of whom had received recognition for their work outside Quebec. Sixteen of the works were videotapes. This was the Musée du Québec's first foray into video art and Déry had done extensive research on the media arts collections in other institutions across Canada and abroad. In a recent interview Déry said she thought it was essential for the provincial museum to make a strong commitment to collecting and exhibiting video art. "It was a duty," she said, given the vitality and importance of video art production in the province.[27]

Sex and controversial political issues were common in the work, but Déry was sure people in Quebec City were "ready," and she was prepared to deal with any objections to controversial work that

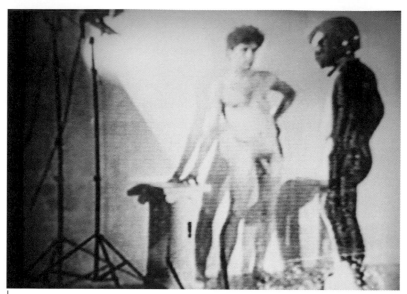

| MARC PARADIS, *Délivre-nous du mal* (1987) video still

might come from the public. She did not realize that the problems
would come from within the museum.

Paradis was an award-winning video artist and the former
director of Vidéographe, the province's largest and oldest artist-run
video production and distribution centre. His tapes had been exhib-
ited widely in Canada and abroad. His trilogy had been purchased
and exhibited by the National Gallery of Canada and his work had
been broadcast on France's Canal Plus. The tapes were central to a
whole body of poetic work produced by the artists of his generation.
Paradis' complex experimental shorts were lyrical explorations of
gay desire and the elusive nature of love. Beautifully photographed
with rich text and imagery, they tested the boundaries between the
reality of everyday life and the imagined world of desire. Nude male
bodies were posed and caressed in dreamy sequences that con-
trasted sharply with the quotidian.

The video component of the show was to be screened in a special
area equipped with monitors and benches, in what was basically a
corridor, just outside the entrance to the large gallery where the

other works (painting, sculpture, photography, installation) were to be exhibited.

Déry had organized the sixteen video works into five different programs. Paradis' trilogy was included with the work of Hélène Doyle and Marilyn Burgess in a program titled *L'expérience des différences*. Déry knew Paradis' work might raise some eyebrows, and so, in the summer of 1990, she had begun discussions with Paradis, other curators, Michel Cheff (the museum's chief curator) and members of the museum's education department about how best to exhibit and contextualize the work. Her preferred approach was to show the program on Wednesday evenings throughout the run of the exhibition and to have an *animateur* there to introduce the work and answer any questions. Paradis agreed to the plan, and the museum's professional staff began preparing for the exhibition to open. However, Déry remained concerned that her approach had not been reviewed by the director of the Musée du Québec, Andrée Laliberté-Bourque. The museum's rigid hierarchy and the pressures of finishing and successfully opening the newly expanded and renovated facility seemed to create an awkward and cumbersome environment for dealing with curatorial questions. Both Déry and Cheff constantly refer to the situation at the time as "delicate."[28]

In January 1991, Déry began writing urgent memos to Cheff, outlining her preferred curatorial approach to the video program and noting other possibilities she considered less acceptable. At one point, Cheff and staff in the education and public programs division of the museum proposed that Paradis' work not be shown at all during the opening exhibition, but "postponed" and screened as a special event during a conference on contemporary video art in Quebec scheduled for the early autumn. Déry's protests put the original plan back on track and Paradis, Cheff, Laliberté-Bourque, and Déry met in April to confirm the details of the exhibition.

According to Paradis, he had been clear with the museum from the beginning: if they did not wish to include his work in the show, he would understand, but if he was selected to be part of the exhibition, he expected them to stand up for his work and the curatorial decisions that had been made. Paradis understood that his work might shock some people; he felt no need to be "aggressive" and

readily agreed to the evening screening schedule, warning signs and introductions from the education staff.[29]

Déry had screened the work for a variety of staff members so a broad cross-section of the museum community would be familiar with the work if questions arose. She said the response was positive, and she felt confident that the quality of the work and the thoughtful plan for the exhibition and interpretation of the tapes would allow the institution to ride out any controversy in a forthright and professional manner.

Paradis attended the official opening of the new museum and the première of *Un archipel de désir* on Saturday, 18 May, and celebrated along with the rest of Quebec's artistic community. His work was listed in the catalogue and everything seemed to be unfolding according to plan. Then, on the following Wednesday afternoon, shortly before his work was scheduled to begin its first screening, Paradis received a call from Michel Cheff saying the work would not be presented that night due to "technical and administrative" problems. The board, it seemed, had not seen the work, or approved it, and the warning signs were not ready. Cheff could not say when the work would be rescheduled. Déry, in Montreal for meetings, heard about the decision when she checked in with her office for messages.

Shocked, frustrated and furious, Paradis contacted Daniel Carrière, who wrote regularly on video art for *Le Devoir*. The museum's private decision became a very public affair. *Le Devoir*, the *Montreal Gazette* and *Le Soleil* all published articles on the incident, implying that the museum was guilty of censorship at worst and gross mismanagement and unprofessional communications at best. Carrière's articles detailed Paradis' discussions with the museum and printed excerpts from the correspondence. All three papers reported slightly differing versions of the events, and the museum's denials and explanations just seemed to muddy the waters. Its machinations appeared absurd. Whether the work was removed from the exhibition or merely postponed became irrelevant. The artistic community sensed censorship and was outraged. Artists, critics, curators and dealers deluged the museum with wor-

ried phone calls and faxes. Anxiety about being associated with a censored exhibition spread throughout the entire milieu.

Laliberté-Bourque hastily convened a meeting of a number of board members to discuss the matter. Paradis' tapes were screened, and Déry's thoughtful and well-researched justification for the work was presented. Apparently the members who were at the meeting decided that the work should be shown. Whether the group was inspired by the tapes, a point of principle, fear of scandal, staff resignations or lawsuits, the "technical and administrative difficulties" were quickly resolved and, according to Cheff, all three tapes were presented the following Wednesday.

But it was too late. Despite the reinstatement of all three tapes, the damage was done. In early June, Paradis wrote to the director asking for an explanation and an apology. When none was forthcoming, he withdrew his work from the show. So did six other video artists in the exhibition (including some of the province's most senior and well-respected producers such as François Girard and Robert Morin), who severely attacked the museum in the press. A letter-writing campaign accused the Musée du Québec of discriminating against gays and lesbians and becoming the "nouveaux curés de la culture."[30] The museum was castigated for avoiding its responsibilities to the artist and for not being accountable for its own decisions.

Cheff's and Laliberté-Bourque's comments in the press implied that Paradis, who had worked for almost a year with museum staff planning the show, was exacerbating matters by acting the impatient bad boy, by contacting the press and other artists. It's just a question of timing and communication, they seemed to say, maintaining an apparently bewildered and vaguely annoyed façade in the face of the hostility that greeted their clumsy attempts to manage the matter.

How could the subject of endless meetings and memos not be resolved by the time of the opening? Did board president Jean-Guy Paquet order two of the tapes pulled as reported in the *Gazette* on 8 June 1991? Did the clergy on the board exercise undue influence? Did Laliberté-Bourque panic at the last minute and fear tarnishing the opening of such a grand project?[31] Paradis could not be made

the scapegoat for that kind of confusion. As Anne Duncan wrote in the *Gazette:*

> That the matter was even raised at the board level seems highly inappropriate. No board of directors of any publicly supported museum has any business meddling in the day-to-day running of an institution.... Those are the jobs of the curators and the museum directors. The board of directors is there to make sure that the administration of a particular institution is efficient, logical, responsible, and professional. It is not to choose the art that will be shown.[32]

What troubled the artists most was the museum's lack of courage, suggested Montreal video artist Daniel Dion, one of those who withdrew his work in protest. Even postponing the screening after all the discussions and negotiations seemed ridiculous and unacceptable. "The museum's management acted as if the screening of Marc's tape was the worst thing that could happen in Quebec, when they should have known that it was just part of contemporary art and that it was their job to educate the public about this work."[33] Cries of censorship and accusations of discrimination against gays and lesbians overshadowed reviews of the exhibition and tarnished the opening celebrations of the new and improved Musée du Québec.

Laliberté-Bourque wrote a letter to concerned artists trying to explain the situation and encouraging them to reconsider their decision to withdraw their work from the exhibition. None of the artists changed their minds and the video component of the exhibition unfolded with dramatic gaps left by the absence of some of Quebec's most acclaimed media artists. The whole affair turned into a nasty débâcle that bruised the museum's reputation as a modern cultural institution and seriously harmed its relationship with the contemporary arts community. The public did not get to see the work so that they could form their own judgements as to its values or artistic significance.

Cheff, Déry and Laliberté-Bourque have all since left the Musée du Québec. Déry's vision of an active program of collecting and

exhibiting video art comparable to those of other major international art galleries and reflective of the reality of Quebec's artistic practice has died at the provincial museum.

▆▆▆ RICHARD FUNG, MARC PARADIS, JOE SARAHAN AND THE NATIONAL GALLERY OF CANADA

I drank champagne on the spring night that the National Gallery of Canada opened its new building and the *New Works* video exhibition that I curated had its première. I dreamed of happy artists, international acclaim and an adoring public.

In the first three weeks of the show, the gallery received three or four telephone complaints from visitors who said that the sexually explicit material in some of the video work had shocked them. It surprised and startled them to see such material in the gallery, particularly, it seemed, when they were accompanied by children.

The tapes ran continuously on three monitors in the gallery on a computer-controlled, pre-programmed schedule. The walls of the video gallery featured an array of artists' statements and personal photographs, stills and tape descriptions. Visitors who passed by the glass doors or walked into the room might see Sarahan's stylized clips of S/M dungeons go flashing by, Paradis' poetic male nudes masturbating, or Fung's "Chinese character" delicately drifting in front of clips from the found footage of a boisterous poolside sex romp. These scenes on their own—isolated from the meaning provided by watching an entire tape, left some visitors disturbed.

The issue for those who complained seemed to be one of making an informed decision about what they wanted to see, and what they wanted their children to see. Nothing in the gallery's opening events brochure drew attention to the content of the tapes in the exhibition.

After discussions and with the agreement of the three artists whose work had drawn complaints, the gallery posted discreet signs on the glass doors of the video gallery that said: "SOME TAPES CONTAIN SEXUALLY EXPLICIT MATERIAL: VIEWER DISCRETION ADVISED. CHILDREN SHOULD BE ACCOMPANIED BY ADULTS." We took a softer

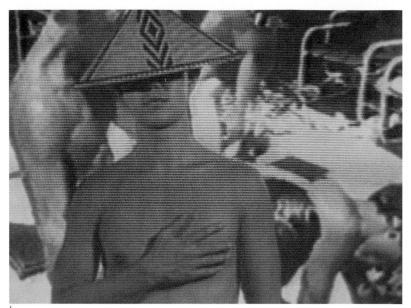

| RICHARD FUNG, *Chinese Characters* (1986) video still

stand on warning signs than the Mendel had. It was hard for visitors to know what to expect from the video gallery and, at that time, we did not feel any political pressure attached to the suggestion that we post signs.

For the next twelve weeks the exhibition continued uneventfully, accompanied by artists' talks, panel discussions, and favourable reviews from the art press and many in the media arts community.

Then, on 11 August, the *Ottawa Citizen* hit the streets with a front page headline—"'Pornographic' videos offend National Gallery visitors"—and, as Sylvie Gilbert says in her essay in this book, "Welcome to the roller-coaster ride!" The following two months were an overwhelming avalanche of discussions with lawyers and the then-ubiquitous Ontario Censor Board; responding to the posturing of Parliament members; hostile media interviews; a vitriolic letter-writing campaign; nerve-racking encounters with the gallery's board of directors; endless arguments about "warning signage;" racist and homophobic telephone calls from members of the public

who had never seen the show; and several anonymous death threats all mailed to me from Timmins, Ontario.

All of the tapes in *New Works* had been approved officially for acquisition and exhibition, although none of the members of the Acquisitions Committee other than Diana Nemiroff, curator of contemporary art, had attended the screening of the work. The gallery's director, Dr. Shirley Thomson, and communications director, Helen Murphy, were informed in advance that some of the tapes might stir up controversy. As the curator of the show, I had prepared extensive dossiers on the artists and the tapes that included résumés, videographies, exhibition histories, critical reviews, lists of awards and prizes, along with a resource file on the history of erotics in the arts and censorship of the arts. While that material proved to be invaluable, it was not enough to make for an easy ride when the controversy arose.

I had been tipped off by a friend working at the local CBC radio station that something was about to happen, even though the exhibition had been open for almost three months. Sources at the *Ottawa Citizen* had informed my contact that a college student had complained to the newspaper that the videos being shown at the National Gallery were "pornographic" and that the newspaper was investigating them. A few days earlier the *Citizen*'s art critic, Nancy Bael, had seen a number of the tapes in the exhibition and had interviewed me. She was full of praise for the work in the opening show and enthusiasm for the whole media arts program.

Nothing in our meeting prepared me for the headline on Bael's subsequent article, which was quickly picked up by the Canadian Press wire service and printed in newspapers across Canada. "'Pornographic' videos at the National Gallery" was not the headline I had expected after our discussion. Apparently it was not what Bael had expected either, and she telephoned me only hours after the story appeared to apologize, shocked and dismayed by the misleading headline and what she considered a completely distorted editing and misrepresentative reorganization of her original article. Like the *Star Phoenix*'s investigative report on the Evergon show at the Mendel Art Gallery, Bael's original text had featured interviews with a number of visitors, most of whom had no problem with the

BEWARE!

These videotapes address many subjects, including PORNOGRAPHIC police practices OBSCENE government negligence, and PERVERSE homophobic censorship

They also include several scenes of explicit gay sex which may offend some viewers and delight others.

To post warning signs or not. That is the question faced by many museums, and it was answered with finesse by artist **JOHN GREYSON** in *Fictional Documents: Gay Culture and the Media,* curated by Barbara Fischer, at Toronto's Power Plant in 1989.

content of the exhibition. It also included a positive analysis and commentary of her own. The final version of the story had put a completely different and largely negative slant on her report.

Despite the hysterical tone of the headline, the attendance at the exhibition was good and the gallery had not received any complaints since the signs were posted ten weeks earlier. According to the article, nineteen-year-old Algonquin College business student Corey O'Neill wandered into the video gallery during his visit to the museum, voiced his disgust about the scenes he saw in a tape and called security guards and urged them to remove two young girls from the video room. He thought the warning signs were not strong enough, and rather than complain to gallery officials, he had gone to the press. In his estimation the video was hard-core pornography.[34]

The day the *Citizen* story appeared, I received a phone call from the Ontario Censor Board demanding that the tapes be withdrawn

from the screenings immediately and submitted to the Censor Board for "review and approval," I declined to do so. A follow-up letter indicated that *based on the press coverage* the Censor Board had seen, the museum was probably in contravention of provincial legislation governing the exhibition of film and video. Consultations with the gallery's lawyers indicated that the NGC, as a federal building, was probably not subject to provincial legisla-

BEWARE!

These videotapes address many subjects, including PORNOGRAPHIC police practices OBSCENE government negligence, and PERVERSE homophobic censorship

They also include several scenes of explicit gay sex which may offend some viewers and delight others.

tion. The tapes continued to play and were not submitted to the Censor Board. On the lawyer's advice, a stronger warning sign was posted and admission to the video gallery was restricted to those sixteen years and over (sixteen being the NGC's cut off point for charging adult admission prices) until the legal experts at the Department of Communications had prepared a formal opinion on the legal ramifications of the Censor Board's demands. This placed the gallery's security guards in the impossible position of trying to police visitors. It was an absurd and completely unacceptable position for the National Gallery to take. I wrote a concerned memo, and the restrictions were dropped. The signage changed when a Canada Council officer wrote an outraged letter complaining that she had been denied admission to the video room because she was carrying her infant son in her arms. The legal opinion supporting the gallery's independent status arrived and nothing more was heard from the Censor Board.[35]

However, plenty more was heard from the press, particularly AM radio talk shows, which were determined to have me "admit" the National Gallery of Canada was showing pornography. The reporters or hosts told me they had never seen the tapes. None of

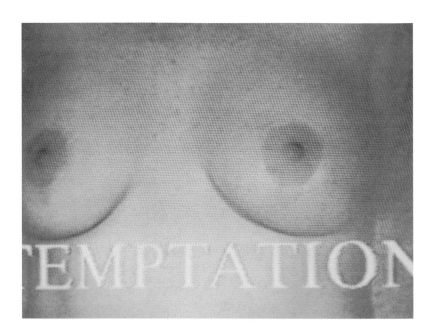

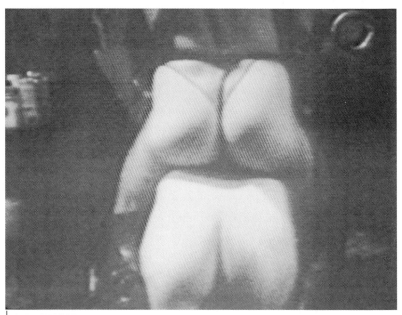

| JOE SARAHAN, *Holy Joe* (1987) video stills

the people who called the gallery to complain about the tapes during this period had seen them. Few, it seemed, when questioned, ever even visited the National Gallery. Most of them had read the newspaper article, though, and suffered greatly from a case of second-hand offence. Most of the callers were blatantly homophobic and several were racist as well, responding, I suppose, to the special attention Richard Fung's work was given in the article. It had the least sexually explicit material of any of the tapes, but as the callers had not seen the work, how were they to know?

Developing a critical perspective on media coverage is one of the toughest parts of dealing with any artistic controversy in an institution. Sensational headlines written by detached editors spark the interest of all kinds of media outlets. Articles are picked up by press services and edited, given new headlines and reprinted in dozens of newspapers. By the time the original piece has circulated for a few days, the basic information may be wrong and opinions may become fact. What starts out as one complaint from one viewer is quickly blown into a national crisis.

A few weeks after the *Citizen* article appeared, Flora MacDonald, then Minister of Communications, began forwarding the NGC copies of letters received by her office (about thirty in all) protesting the exhibition and urging her to stop "the smut at the National Gallery" and "the presentation of depraved, lewd, obscene, and unnatural acts that are outside normal sexual relations and degrade all human life," to "keep the museum clean and beautiful" and not "contribute to violence against women, the sexual abuse of children and the rising cost of social workers."[36] It was evident from stickers on the envelopes and attached mail-in coupons clipped from a newsletter that the campaign was organized by a right-wing religious anti-abortion group called Human Life International. The Minister's form-letter reply was a testimony to the crucial importance and strength of the arm's-length tradition at the federal level.

Although Miss MacDonald is the Minister responsible for museums and galleries she is prevented by long-standing convention and the firm commitment of this government to the

August 11, 1988

Editor
The Citizen
1101 Baxter Road
Box 5020
Ottawa, ON K2C 3M4

Dear sir:

I trust you will permit me to set out some background on the Richard Fung video,
"Chinese Characters," which provoked today's page one article in the "Citizen":
"'Pornographic' videos offend National Gallery visitors."

The artist today, as always, holds a mirror up to society, and the gallery's man-
date is to put the artist's work in a social and art-historical context, and to
exhibit and explain the work and its relevance to us.

The artist in these last decades of the 20th century sees, and makes us see, many
uncomfortable and disquieting things about our society. Our sexual relations can
be seen as a metaphor for how we love—or do not love—our fellow human beings, and
it is this aspect of our lives that artists have used through the ages to
describe the universe of human, not just "sexual," relationships. Fung's video,
about Chinese immigrants to a strange (to them) culture, is indeed disturbing.
But it is not, in our view, pornographic, although it is very frank. The partic-
ular images, of masturbation for example, are only a part of the entire work the
artist wishes us to see. The act itself, a passionately isolated one, is only
part of his overall statement about human loneliness and separation.

The Fung video is part of a continuing contemporary film and video program, most
of the works by Canadian artists. Because, as I noted earlier, our human and
sexual relations are part of artists' exploration of our society, there are occa-
sionally explicit scenes, and so we have provided ample signage advising our
visitors. We also require the security guards to exclude viewers under 16 from
the Video room.

Yours sincerely,

Shirley L. Thomson
Director

| National Gallery director Shirley Thomson sent this letter to all the newspapers who
printed articles attacking the video art as pornography.

arm's-length principle from becoming involved in curatorial or artistic decisions made by cultural agencies in her portfolio.[37]

In the meantime, NGC director Dr. Thomson viewed Richard Fung's tape in my office, wrote and circulated a letter to the editor defending the work. The director wrote a similar, polite but firm, reply to all of the Human Life International letters and the handful of other protests that had been received. Letters supporting the exhibition had started to outnumber those protesting it, and after its splashy and sensational "porn" headlines, the *Ottawa Citizen* published an editorial that affirmed the gallery's public responsibilities:

> Predictably, one outraged viewer said taxpayers' money shouldn't be used to purchase this kind of material for the National Gallery. It can be argued that some of the Gallery's contemporary art deserves to be laughed out of the Gallery. But none of it—neither the "obscene" nor the absurd—should be hounded out. If curators caved in to fear, as opposed to ridicule, they could eventually give us an "uncontroversial" Gallery. Inoffensive because it would be empty.[38]

London East Conservative MP Jim Jepson generated new headlines in mid-August, when he raised the matter in the House of Commons. Outside the House, he said, "The videos represent the overly liberal thinking of certain members of the country's art community and the federal justice department.... Too much freedom was being taken with art."[39] He also suggested the government should set up a committee to investigate the exhibit. His comments died in the House and no action was taken.

The National Gallery's board asked to see the tapes after the questions were raised in Parliament, and tensions rose when they wanted to screen excerpts because of time restraints. I refused, imagining these complicated works being reduced to "just the dirty bits," and instead screened all of Richard Fung's tape for the board members. In my admittedly warped memory, they were almost all wearing military blazers, except for artist Molly Bobak, whose impassioned commentary about the work after the screening short-

380 Sussex NW 9N4 613 990 1985

ational Gallery visitors object to videos

Genitals and homosexual acts

AWA (CP) — The National
: may call it art, but Corey O'Neil
ner visitors say Richard Fung's
t Characters is pornography.
il, a 19-year-old Ottawa student
w the Fung work on three televi-
reens in the video room of the
porary galleries last week, says:
uldn't believe they would show
aterial in the National Gallery.
deo showed close-ups of male
s and intercourse between males.
rly liberal-minded, but at that
eft in shock."
ld gallery security guards of his
and asked them to get two young

girls out of the video room.
"In my estimation, that video is
hard-core pornography," O'Neil said.
A sign outside the video room says:
"Attention. Some videotapes contain
sexually explicit material. Children
should be accompanied by an adult."
Although security guards have been
given strict orders not to let in children
under 16, guards are not always at the
door.
Edith Brown, of Strathmore, Alta.,
shocked by a video showing masturba-

tion and homosexual sex, said:
"If people want to watch that sort of
film in their own home, fair enough. But
the National Gallery is an open space
and I don't think taxpayers should be
paying for pornography that very young
people have access to."
Brown said she called the gallery's
information line later to complain and
was told by the person answering that
several other people had complained.
But for Susan Ditta, assistant curator
of film and video, the videos are un-

questionably works of art which exp
difficult questions of our time — se
identity and the role of the media
people's lives.
"People accept images that are
as violent and sexual when they ar
the European or Canadian histor
galleries," Ditta said.
"The rape of the Sabine Wome
Blair Bruce's frolicking lesbian nu
or Degas's prints of brothels don't m
them angry because these images
regarded as art history. They h
become sanitized in people's minds
sanctioned."

You hypocritical Pervert - How dare you call Such pornographic filth, Art, If you want to stay healthy, then get rid of those tapes and don't show them aga We know who you are and how to reach you, pervert.

| Threatening letters to National Gallery curator Su Ditta were scrawled on copies of the newspaper article that sparked controversy around a video exhibition.

circuited any negative reaction. If the board ever discussed pulling the tapes or closing the show, nobody would admit it to me.

The artists endured the indignity of being labelled pornographers. I dealt with demands that I should be fired, along with threats "to get" me for being a "fag-lover" if I didn't cancel the show. The threatening letters were all scrawled on copies of the original *Ottawa Citizen* article. Harder to cope with by far was the cold shoulder I received from some of the gallery's professional staff who clearly felt the video exhibition had somehow gone too far. It made the last weeks of the exhibition seem an eternity and gave the show a tiresome afterlife.

However, Dr. Thomson's support remained steadfast; she attended panel discussions and met with the artists. Helen Murphy's expertise in communications proved invaluable in composing letters to the editor, replying to written complaints and particularly in teaching me how to handle radio and television interviews. The thoughtful commitment of the artists in the show and many members of the media arts community who rallied letters of support, along with the critical help of local gay and lesbian organizations,[40] all contributed to our ability to make sure the exhibition continued uninterrupted until its scheduled close on 5 September 1988.

The NGC emerged from the tumult seemingly unscathed, funding intact, audiences and memberships increased, reputation in the art world enhanced, and curatorial freedom and exhibition process unchanged. Suddenly, after several months of turmoil, it was all over as quickly as it had begun. It was an exhausting experience for everyone involved, but ultimately a very positive one. Subsequent video programs with similar work garnered no negative attention.

If any of the grey nuns saw the videotapes they kept their horror, enchantment, or titillation to themselves. Nobody committed suicide. My nightmares stopped.

In all of these case studies, museum directors and curators share some similar experiences. The anxiety manifested by my nuns is to be expected and it is hard to take. You cannot help feeling isolated and that somehow you have made or are about to make a terrible mistake. That the timing is wrong. That you do not have the resources to "handle" things. Especially in the beginning when the press and the letters are all negative. Dealing with personal anxiety and private demons becomes inextricably linked with the larger legal, financial and social implications of programming controversial work.

All of these institutions discovered that artists are capable and prepared to defend their work with or without the museums' help, and that the wrath of an artistic community betrayed is as powerful if in a different way as that of an outraged politician or citizen.

Managing the media and possessing the ability to match the censorious, sound-bite for sound-bite, is a crucial tool of the trade for contemporary visual and media arts professionals. Working effectively with communities and members of the art-going public to defend the principle of curatorial and artistic freedom is an equally valuable skill.

Being pro-active in positioning the institution in the community as a public site for discussion and debate has become essential in the 1990s. At a recent conference organized by the Ontario Association of Art Galleries, Toronto video artist Lisa Steele put it this way:

This would be an ideal time to implement a completely new strategy within the gallery system. That would be one that would look at the actual history of both the collections and the current programming, and have the galleries and museums of this country finally start to expose the kind of controversy that has existed within all their art works, so that the public isn't surprised by controversy, but in fact welcomes it, and the galleries and museums become a site of debate and lively interjection.[41]

Controversies over art are important. They signal larger cultural crises and social change. Resistance to controversial work is often a thinly veiled cover-up of fear: fear of discussing the critical issues invoked by the work and fear of eroding traditional attitudes and structures. Demeaning artists and the different voices they bring into the mainstream of the public sphere is a way of silencing new perspectives and shoring up the old. Museums and galleries should have the courage to open windows on those debates, not close them. Communities are made richer by difference and nonconformity, and museums, of all places, need to recognize this. Vigorous artistic expression and debate are directly linked to the well being of society, and institutions with the art-historical knowledge of the past have an obligation to take risks and expand the possibilities of human imagination. Even when the art is about sex. Even when it makes some people uncomfortable.

The current political climate may always be hostile to work about sexual difference, sneering and vindictive when it is pushed to the front of the cultural landscape. Nobody said it would be easy. As public institutions, galleries have an obligation to confront their fears and the impulse to suppress important work. They have a responsibility to educate their boards and their staff, and to get smart at managing the press and ambitious politicians. It's their job.

Summer 1996

N O T E S

Special thanks to Sylvie Gilbert for editorial insights, and to Karen Knights for research.

1 Brenda Cossman, *Censorship and the Arts: Law, Controversy, Debate, Facts* (Toronto: OAAG, 1995), 11.
2 The initial 1993 charges against Langer and Mercer Union director Sharon Brooks were dropped, but five paintings and thirty-five drawings were seized by the police and the Crown applied for a forfeiture application. The work was returned to Langer after the Crown lost its case in 1995.

3 Cossman, 27.

4 Quoted in Barbara Daniel, "The Balance of Convenience," *Parallélogramme* 9:5 (1994), 12.

5 F. Feldman, S.E. Weil, S.D. Biederman, *Art Law: Rights and Liabilities of Creators and Collectors* (Boston: Little, Brown and Company, 1993), 179.

6 Philip Palmer, "Confused: Sexual Views: Paul Wong vs. The Vancouver Art Gallery and Luke Rombout," *CARFAC News* 12:2 (June 1987), 2–5.

7 Barbara Daniel, "The Balance of Convenience," *Parallélogramme* 9:5 (Summer 1984), 12.

8 Editorial, *Vancouver Sun* (25 February 1984), A3.

9 Editorial, *Vancouver Province* (5 March 1984), 14.

10 Elspeth Sage, "Ethics and Art," *Parallélogramme* 12:4 (1984), 28.

11 Sara Diamond, "Clear About Confused," *Video Guide* (Spring 1984), 7.

12 Elizabeth Phillips, "Evergon but not Forgotten," *Newest Review* (June/July 1990), 6.

13 Terry Craig, "Art Display Restriction Sought," *Saskatoon Star Phoenix* (12 December 1989), A3.

14 Terrence Goudy quoted in "City Stays out of Display Dispute," *Saskatoon Star Phoenix* (12 December 1989), A8.

15 Liam Lacey and Isabel Vincent, "Saskatoon Gallery under fire for 'Offensive' Exhibition," *Globe and Mail* (23 March 1990), A13.

16 Craig, A3.

17 Ibid.

18 S-P Opinions, "Art Criticism Left to Experts," *Saskatoon Star Phoenix* (16 December 1989), A2.

19 "Councillors at Odds over Mendel Displays," *Saskatoon Star Phoenix* (3 January 1990), A2.

20 Art Robinson and Mary-Jo Laforest, "Thompson Quits Mendel Board over Policy Concerns," *Saskatoon Star Phoenix* (9 April 1990), A3.

21 Legislative and Finance Committee, *Mendel Art Gallery Exhibition Policy*, Report No. 14 (9 April 1990), 2.

22 Phillips, 6.

23 Lacey and Vincent, A13.

24 Ibid.

25 Bruce Grenville, telephone interview with author, May 1996.

26 Ibid.

27 Louise Déry, telephone interview with author, June 1996.

28 Michel Cheff, telephone interview with author, June 1996.

29 Marc Paradis, telephone interview with author, June 1996.

30 D. Langlois, A. Golden, R. Lavoie, P. Chackal, P. Sypnowhich, S. Downs, A. Klusacek, "Ingérence discriminatoire," *Le Devoir* (31 July 1991), Letters to the Editor, 12.

31 This seems to be a recurring theme in Canada. Capital funds from both the public and private sector are raised with the support and commitment of the arts community because museums promise that their new facilities will feature an enhanced program in the contemporary arts. This gives the institution a certain cachet and contributes to the mesmerizing notion that it is world class, leading

edge and yet more rigorously than ever dedicated to the local sense. Memberships increase and those who had been disdainful or excluded join the enthusiasm for a new era in a new institution. Heritage functions, research and new critical thinking will all be catapulted to new horizons under the roof of fresh drywall and redesigned letterhead. These endeavours also bring a higher public profile and closer contact with the realities of contemporary art practice. Suddenly, the institution has to sink or swim with its own hype.

32 Anne Duncan, "Museum Accused of Censorship," *Montreal Gazette* (8 June 1991), J1.

33 Daniel Dion, telephone interview with author, June 1996.

34 Nancy Bael, "'Pornographic' Videos Offend National Gallery Visitors," *Ottawa Citizen* (11 August 1988), A1.

35 All museums and galleries in the province (except for a handful of federal institutions) were subject to the authority of the Ontario Censor Board until later in 1988 when the regulations of the Ontario Theatres Act were amended to exempt them, providing admission was restricted to adult audiences.

36 Excerpts from letters in National Gallery of Canada files.

37 Hon. Flora MacDonald, response to letters from the public, 21 October 1988. This was the stock response to all who protested the exhibition.

38 "Sex Advertised and Sex Displayed," *Ottawa Citizen* (12 August 1988), A3.

39 Randy Rat, "Jepson Labels Gallery Videos 'Pornographic,'" *Ottawa Citizen* (18 August 1988), A5.

40 The press coverage of the exhibition reached its peak just when a panel discussion on approaches to gay sexuality, class and race in contemporary video was scheduled. The Ottawa Gay Business Association organized its members to attend in large numbers. There was no protest from anyone.

41 Lisa Steele, presentation at the OAAG Conference on Censorship, Toronto, Spring 1995.

The cheerfulness of the 1960s sexual revolution—with its fresh optimism about the liberating potential of free love and the pill and *Playboy* magazine—has long since been superseded by more anxious debate about the erotic and its representations.

Flesh and the Devil

EROTICISM
AND THE
BODY POLITIC

In the volatile arguments among feminists, the state and postmodernists, to name only three discourses that have surfaced in the past thirty-five years, human erotic possibility has been here and there inflated or demonized, variously deconstructed or regulated, as each argument has come to terms with the powerful and destabilizing possibilities of sexuality. What is sex for? How will we talk about it? Who will speak? Who will be prevented? What does it look like?

Myrna Kostash

Listen to redoubtable American feminist Robin Morgan, for instance, on the male hero in *The Demon Lover:*

> Because he carries within him the double potential of triumphal power and sacrificial power, he personifies in patriarchal terms all that remains to us—after centuries of manipulation, diminution, and corruption—of what once was passion. We can follow his trail back in patriarchal time, with the blood spots as spoor.[1]

I pick this text as a readily available artifact of a certain way of speaking about the (alleged) erotic that feminism and its adherents once cleaved to. Exalted by rage and bitterness, the post-1960s female revolutionary attacked (hetero)sexuality as one more site of the violent processes of colonialism—Morgan's vocabulary could easily be employed to attack colonialist depredations of the Third World—that had to be resisted, rooted out and expunged from the psychic jungles of desire.

As embarrassed as we may be now by the unsophisticated denunciation of such an awesomely complex construct as "patriarchy"—or

117

even "he"—we nevertheless are indebted to its purgative power. Thanks to the angry, intemperate and inflammatory speech of the anti-heterosex squads, there lies only a scorched path back to discourses of male sexual privilege and female frigidity, of the "intimacy" and "privacy" of the sex act, of male sexual consumerism as "pleasure," to mention only a few of the exploded arguments. As performance artist Holly Hughes reminds us, feminism had to de-eroticize sexual relations so as to reinvent (female) sexuality.[2] There seemed no other alternative, given the universalizing arguments in western culture that female nature resided in a woman's genitals, her virtue in her sexual abstinence and her agency in her sexual repression. On the erased slate of the body our new and liberated desire would be reinscribed.

But it is a politics of despair, this profound pessimism about heterosexuality that functions as a social critique of sexual relations. We wanted to speak of our fury about power and injustice but found ourselves revolted instead by the body.

We can see now the source of the despair—in the deep frustration at the slowness of the revolution and the global expanse of the commercialization of sex and women's bodies. Where once feminism stood its rationalist ground, analyzing and theorizing the politics of sex and gender as they played out in the material world of economics and physiology, building a case for the liberation of women from historical necessity, now the talk was all of revulsion and outrage and pain around (hetero)sex itself, as though the act of coitus, and not society or history, was the source of women's subordination. It was understood that no woman would *freely* choose intercourse, vaginal penetration being somehow "excessive and irrational."[3]

The humiliation of women then seemed complete when, in response to the revolutionary agitation of the 1960s and 1970s, and to the appropriation by women of their own pleasure, there came "debasement, defilement and torture, all artistically packaged and presented as eroticism and pornography" in the words of French feminist Benoîte Groult.[4] In this feminist discourse pornography is something *done* to women, it *is* rape, battery, torture, harassment, humiliation, harm, sexual abuse, not to mention political persecu-

tion. In this hyperbolic account of women's helplessness, the elision of the *representation* of sexual abuse with abuse itself makes no allowance for women's own agency. Pornography carries only one meaning—violence—and admits only one gaze—male.

In this early engagement with the pornography/censorship issue, some feminists and artists sought to make a distinction between pornography and erotica, accusing the former of being on the side of "death," or the masculine passions, while the latter promotes sexual tenderness, nurturance and intimacy, the feminine virtues.

Conversation on CBC *Ideas,*
"Feminism and Censorship":

Max Allen: A spokesman for Project P—that's the pornography squad of the Ontario Provincial Police—said that ...

Su Ditta: ... that explicit sex was going to be permissible if, and only if, there was romance, no closeups, and a story line. And as someone who's spent a great deal of time writing about the deconstruction of narrative in contemporary video art practice, I got really worried about there having to be a story line.[5]

In what became known as the story line of "vanilla sex," the experience of erotic authenticity was possible only under conditions of equality and with a completely rewritten narrative structure. The lovers:

> are in love,
> have a meaningful relationship,
> don't hurt each other,
> don't exchange money,
> think of something besides fucking to do.

Ideally they should be women.

Despite the professed "pro-sex" tone of the story line, the suspicion is unavoidable that what was found scandalous in porn was its frank "sexual address," its *intention* to arouse the viewer. Erotica, by

contrast, is meant to be "about" equality and mutuality. In the repre-
sentation of the tender embrace of lovers who respect each other
and tend to each other's swooning soft-focus satisfaction, the poli-
tics of dominance/submission is overthrown and the pro-woman
regime of *affection* is established.

Even the notorious sex performance artist Annie Sprinkle, whose
work addresses the overlap of performance with pornography and
prostitution, is less interested in lust and arousal than in sexual
"self-knowledge" and even argues that sex is "about" energy and not
about "the way bodies touch."

> Annie Sprinkle's Guidelines for Sex in the '90s: Learn About
> Your Breath: Sexual and orgasmic energy travel on the breath.
> (It's possible to have an orgasm from breathing alone. Is this the
> safe sex of the future?)[6]

In this flight from the flesh, the state and its instruments have
been fully present. Now more a criminalizing than moralizing dis-
course, the laws of the land seek to reduce hard-core sexual
representation to one context—legalized definitions of pornog-
raphy. Even the new concerns with civic sexual rights have been
assimilated to the criminal codes. What had once been the subver-
sive speech of the marginalized—women, homosexuals,
children—is now the legislated speech of the authorities who speak
for them.

In the 1992 Butler decision of the Supreme Court of Canada, the
"degradation" of humans and the "harm" that may be done them
from the free circulation of "obscenity" were cited as reasons to
prosecute purveyors of images of explicit sex and violence. The
decision was hailed in some corners as the ultimate protection of
women and children who are the main "victims" of *images* of vio-
lent, exploitative and explicit sexual acts. The issue is no longer
"sin" or "perversity," but the social inequality of women—which is
somehow to be corrected by the *absence* of what we once inno-
cently called dirty pictures. From other corners, however, came a
hue and cry of warning that the state is less (much less) interested
in the well-being of women and children than in the criminalization

of gay and lesbian imagery—and that in any case the state is too blunt an instrument to make the distinction between nice "erotica" and bad "degradation."

The melancholic irony is that in spite of the enthusiastic support from many feminists for the Butler decision—hoping for a crackdown on the sale of hard-core heterosexual porn—the state has moved almost exclusively against gay or alternative or marginal materials. In the first legal decision after Butler, materials seized by Canada Customs on their way to Glad Day bookstore in Toronto were found in 1992 to be "obscene," including "vanilla" depictions of gay sex. In February 1993 another Ontario Court judge ruled against the importation of the American lesbian magazine *Bad Attitude*, finding obscene (under Butler) the image of a woman being stalked in a shower by another woman intent on having sex. In his ruling, Judge Claude Paris feared the material would "predispose individuals to anti-social behaviour." On the other hand, no charges were ever laid against Madonna's book, *Sex*, whose explicit, titillating fantasies of the rock star's submission to the embrace of the heterosexual hero apparently offended no one.

In 1993 a hastily drafted and debated bill, C-128, the so-called kiddie-porn legislation, criminalized material that shows a person who is (or is depicted as being) under the age of eighteen "engaged in" or "depicted as engaged in" explicit sexual activity. As arts groups protested at the time, the wording is broad enough to criminalize *The Boys of St. Vincent, My American Cousin* and *Loyalties*, not to mention episodes of *Degrassi High*,[7] and lays the onus on the artist to prove his/her work has "artistic merit," even while in the actual, existing world of teenagers, fourteen-year-olds can legally have sex!

Never mind that there are provisions within the criminal code that can be used to charge people involved with the production of child pornography. Approved *unanimously* by the House of Commons, the new legislation seemed to have as its purpose to position the state on the side of those who, in the very murky debate about the impact of images on behaviour, argue that pornography hurts people—in effect, that it constitutes an *act* of aggression or violence. Never mind that with pornography we are dealing with

imaginative rather than social acts, with representation, not the act itself. Although the argument has shifted in the past generation from the high ground of public morality to the more mundane terrain of public order, the state is still squarely situated as supervisor of public hygiene, thanks in part to the sex-hostile anti-porn campaigns of feminists and their supporters for the past decade.

The first person to run afoul of the new law was the Toronto artist Eli Langer, whose sexually explicit drawings of adults and children were carted by the armful out of Mercer Union, an artist-run centre, by Metro Toronto Police's morality squad in December 1993. Both Langer and the gallery director were charged with displaying and possessing child pornography, even though no real children had ever been involved. Similarly, in July 1995 an Ontario man distributing child pornography on a computer bulletin board was found guilty under the "kiddie-porn" law, although the assistant Crown attorney in the case admitted his materials were "all in his fantasy, all the workings of his perverted mind," with no evidence at all that he had actually physically harmed any real-life children.[8]

Meanwhile, in Alberta, arts groups were warned in 1994 by the minister responsible for Alberta Lotteries not to expect "handouts" of public money for performances not "in relationship to the views held by the vast majority of people in this province."[9] No one in government offered a definition of these views, although the Community Development minister averred that "pornography is a hard thing to define but I know it when I see it."[10] At issue were Catalyst Theatre's feminist satirical revue, *The Tit Show;* The New Gallery's *Bound to be Tongue-Tied: Gagging on Gender,* which advertised performances of cross-dressing and body-piercing; and, most notoriously, the lesbian performance piece *True Inversions* by Kiss & Tell, at the Walter Phillips Gallery. While no laws had apparently been violated, government members were incensed that a "government-funded institution" had been the venue for a "God-awful" and "abhorrent lesbian show." The right-wing weekly *Alberta Report* was most upset that the money for this "free-admission spectacle came from the empty coffers of indebted governments,"[11] an intriguing line of argument that locates redneck anxiety in an economic rather than moral crisis.

Has there ever been such a dialogue at cross purposes between art and authority since the last *fin de si cle* scandals? Even the embittered speech of anti-porn feminists in the 1980s still assumed a community of interest between government and society; indeed, the state was called on to rectify injustices and inequalities—and to police images!—as though it were an extension of women's will. In the 1990s, that assumption lies shattered in the ateliers of the post-modern.

"We're here, we're queer and we won't go away" says the multi-media artist Celine Godberson.[12]

A rereading of the 1980s feminist anti-porn texts (for example, Robin Morgan's cited earlier) in the light of 1990s debates is revela-tory. Since then what *hasn't* been subverted and queried by the new critical theory? The notion that we all agree on what we mean by "manipulation," the acceptance of the continuity of the "patriarchy," and, of course, the idea that the word "he" stands for an undifferen-tiated mass of male identity, have long been contested.

There is not a single idea in the following quote from Toronto anti-pornography writer Susan Cole that has not been undermined by the radical retheorizing of meaning and representation:

> I can begin to see these [pornographic] narratives feeding into a rape culture, creating a generation of male sexual predators, and now that women are getting more into it, a generation of women getting off on sexual submission.[13]

Not only does the argument make vast assumptions about the way a society communicates with itself and about the seamlessness of sexual identity, it attributes everything to masculinity, "thereby inflating male power and impoverishing [women]," as the American anti-censorship feminist Carole Vance cautions us.[14] Given the rad-ical critique of Foucauldian, queer and lesbian artists, it is simply no longer possible to argue for the "inherent" violence of male sexuality or the misogynist "coherence" of the pornographic text or the literal-ness of communication.

Artists have problematized all such arguments on aesthetic and political grounds. No one wants to submit her imagination to the

commissars of vanilla sex; the very notions of audience point of view and community standards are undermined by the articulation of shifting identity; and many rebel against the simplistic, reductionist notion that desire must be purified of power in order to serve lovers' civic need. Are we even being realistic, asks Mariana Valverde, to prescribe an egalitarian, pro-woman society where lovers speak with one conventional voice and it is soft?[15] Who if not the artists will remind us that our sexual speech is issued from a multiplicity of voices and that in such diversity lies our cultural survival against the threat of psychosexual conformism?

In the subversion of humanist (including feminist) speech, there is a deep scepticism regarding grand statements and claims made about nature, reason, progress, beauty. Such categories and their referents have become unstable. *All* difference—not just bi-polar gender—has become eroticized. The transgressive has queered sex practice and ruptured mere porn. And the self, the I, the autobiography have become sites of meanings in an aesthetic where nothing is predetermined. So performance artist Holly Hughes puts on make-up and determines "what I think it's *about* for myself."[16]

> Imagined Voice 1: *Ooooh, suck my ear lobe!*
> *I'm in charge here. When I boot up my fantasies, when I imagine my pleasure, when I wallow in my jouissance, history and society are outside the door, cooling their heels in the corridor. Don't preach at me that I can only come to the strains of erotica, only when I'm in love. Hey, get a life! If I want to punch my nipples with nose rings and get gang-banged by a troupe of teenaged skinheads, that's my business. I want it quick, I want it messy, I want it in the dark.*
> *And don't tell me I'm not a feminist.*
> *Call me a laissez-faire transgressive femme.*

So detached from the discourse of social improvement is this kind of speech that it is always more interested in identity than in collectivity, in the reiterated values of the *self*-defined, the *self*-explored, the *self*-empowered; it is more interested in representation than in agency, in the *autonomous* freedom to imagine and in the

exaggerated claims made for the individual gaze. The artist Naomi Salaman admits that representation will not "effect a social reversal of power" but it can affect the "scopic regimes" that govern how we see the links between objects and what they signify. "This can translate into new knowledge, new 'abstract power' in the debates of pleasure and representation."[17] Sexuality and its imagination are self-referential, an identity *sui generis* that is largely informed by the intuitive and concerned with the "phenomenon of intimacy where it exists without the compensation of social or cultural consent," in the words of the Mercer Union about Eli Langer's taboo-breaking images.[18]

Yet there is something also irredeemably utopian in the transgressives' vision of privileged sexual energy that recalls the 1960s romance with revolutionary possibilities of the unleashed, unrepressed polymorphously perverse. Against earlier beliefs that certain people did not "deserve" sex or pleasure, the new art aestheticizes precisely the queer, the promiscuous, the crossgenerational, the public and theatrical, the violent body as incarnate freedom.

"But we are not free to choose our performances or masquerades at will," noted the British feminist Lynne Segal.[19]

Imagined Voice 2: *So we're not impressed. You think your jouissance arrives out of the blue—you summon it up and it's there? Everything else knocking about in your brain has come mediated by power and relations of dominance—but your jouissance comes free?*

Granted, as the postmodernists remind us, the difference between the representation of reality and reality itself requires two different kinds of responses—presumably the aesthetic and the political. But there is something unbearably weightless in this new stance *against* coherence, authority and interpretation, this condemnation of modernity, and its "curse upon the Enlightenment and all its works."[20] This assertion of the discontinuity of self and other, and the artists' apparent obliviousness to the old categories of history and economics, lets loose the artistic imagination as though it

were schizophrenic, uninterested in context or the shared experience of the course of events.

"Flesh comes to us out of history" said the British writer Angela Carter.[21]

In the urgency of constructing the erotic biographies of the newly visible naked bodies of women, children and queers, the transgressive art practices of the 1990s overly privilege, it seems to me, the sexual. Much is claimed for the power of the represented body, especially the gay or lesbian one, as the "affirmation" of an artist's "entire existence," of "totality," and an expression "on every level of the cultural paradigm."[22] "Who we love," claims Celine Godberson, "affects our every moment as humans," presumably crowding out the human who also works, thinks and mourns lovelessness.

In the scrupulous articulation of erotic difference and bodily self-making/unmaking, we run now the risk of such radical fragmentation or "otherization" that there is no speech that can "speak across"[23] now decentred communities. While political scientist Somer Brodribb's fear of the totalitarian implications of postmodernism's ethic of "separation, discontinuity and dismemberments[24] is perhaps extreme, there is an unhealthy quality to the hyper-significance claimed for the erotic. In our post-socialist world, the erotic has to bear all the feeling and meaning that has been detached from the rest of our social life as we claim, postmodernistically, to mistrust connection, solidarity and communication, not to mention oppression and struggle.

If our sexuality is an *attitude* and not the outcome of our history with others, then we are truly alone, for it is difficult to imagine how, in terms of the deconstructed erotic relationship, we are to talk about a future in which we are all present together. In the over-emphasis on the solipsistic value of fluidity, rupture and difference, we banish ourselves to a privatization and discontinuity so intense that even sadomasochistic violence may not be able to break our loneliness.[25]

Of course the artist will always dream outside the normative. So it is up to us who experience the art to reclaim it in dialogues with each other, with the ancestors and with an imagined future. Just so it makes sense.

Spring 1995

N O T E S

1 Robin Morgan, *The Demon Lover* (New York: W.W. Norton, 1990), 54.

2 Holly Hughes, interview, "Angry Women," *RE/Search* 13, 100.

3 Eileen Phillips, "Introduction," *The Left and the Erotic*, ed. Eileen Phillips (London: Lawrence and Wishart, 1983), 34.

4 Beno te Groult, "Night Porters," *New French Feminisms*, ed. Elaine Marks et al. (New York: Schocken, 1981), 68.

5 Max Allen, producer, "Feminism and Censorship," CBC *Ideas*, (Toronto: CBC, 1993), 15. Radio program transcript.

6 Annie Sprinkle, interview, "Angry Women," *RE/Search* 13, 25.

7 Daniel Lyon, "A bad law on child pornography," *Globe and Mail* (22 June 1993), A17.

8 Stephen Bindman, "Kiddie porn showdown," *Edmonton Journal* (17 July 1995).

9 Corinna Schuler, "No cash for controversial art," *Edmonton Journal* (25 May 1994).

10 Ibid, 1.

11 Rick Bell, "Kissing and Telling in balmy Banff," *Alberta Report* (7 December 1992), 33.

12 Celine Godberson, "Pride Is a Gay Word," *Artichoke* 5:2 (Summer 1993), 19.

13 Max Allen, 13.

14 Carole Vance, "Pleasure and Danger: Towards a Politics of Sexuality," *Pleasure and Danger: Exploring Female Sexuality*, ed. Carole Vance (New York: Routledge and Kegan Paul, 1984), 5.

15 Mariana Valverde, *Sex, Power and Pleasure* (Toronto: The Women's Press, 1985), 43.

16 Holly Hughes, 100.

17 Naomi Salaman, "Regarding Male Objects," *What She Wants: Women Artists Look at Men*, ed. Naomi Salaman (London: Verso, 1994), 23.

18 Kate Taylor, "Show breaks sex taboo," *Globe and Mail* (12 December 1993), A9.

19 Lynne Segal, *Straight Sex* (Berkeley: University of California Press, 1994), 208.

20 Tony Judt, "At Home in This Century," *New York Review of Books* (6 April 1995), 14, in an essay about Hannah Arendt.

21 Angela Carter, *The Sadeian Woman and the Ideology of Pornography* (New York: Pantheon, 1978), 11.

22 Celine Godberson, 18.

23 Wendy Waring, "Introduction," *by, for & about*, ed. Wendy Waring (Toronto: The Women's Press, 1994), 22.

24 Somer Brodribb, *Nothing Mat(t)ers: A Feminist Critique of Postmodernism* (Toronto: James Lorimer, 1992), 19.

25 Jessica Benjamin, "Master and Slave: The Fantasy of Erotic Domination," *Powers of Desire: The Politics of Sexuality*, ed. Ann Snitow et. al. (New York: MR Press, 1983), 296.

MUCH SENSE: EROTICS AND LIFE

6 November 1992 – 24 January 1993
All works courtesy of the artists unless otherwise indicated.

■ MAUREEN CONNOR

Untitled (1989)
steel, wax, body suit, rubber straps
203 x 122 x 20.4 cm

Untitled (1990)
steel, rubber straps, mirrors
183 x 30.5 x 38 cm

Thinner Than You (1990)
body suit, stainless steel dress rack
152.5 x 40.7 x 20 cm

No Way Out (1990)
net body suit, steel armature, rubber straps
203 x 61 x 61 cm

Wishing Well (1990)
net, rubber, pennies
203 x 35.7 x 43.2 cm
Works courtesy Germans van Eck Gallery

■ KISS & TELL
Persimmon Blackbridge,
Lizard Jones, Susan Stewart

True Inversions (1992)
swing, C-prints, chalk, live-feed video camera, colour monitor
installation area 4.2 x 9 x 11.6 m

True Inversions (1992)
performance, 60 minutes
written, produced and performed by
Kiss & Tell

PERFORMANCE
Jolene Clarke, technician/ assistant lighting design; Suzo Hickey, slide technician/props; Ali McIlwaine, technician; Persimmon Blackbridge, script editor; Lizard Jones, recorded sound; Susan Stewart, still photography; Ann Ravin, lighting design; Susan Madsen, swing design; Penelope Stella, acting coach for opening sequence; Gina Stockdale, acting coach; Margaret Dragu, movement coach; Paul Lang, video editor for porn sequence; Mary Alice, video editor for swing sequence; Della McCreary, performance assistant/ catering, Emily Faryna, music and performance (*I've Got a Big Gun,* 4 minutes, *Wenn ich mir was Wünschen Dürfte,* 4 minutes) written by Friedrich Hollander (1930)

VIDEO PRODUCTION
Lorna Boschman, director; Ali McIlwaine, performer/script co-writer; Kim Blain, videographer/camera; Paul Lang, lighting camera; Shani Mootoo, camera; Pat Feindel, camera; Louie Ettling, sound; Emily Faryna, music; Persimmon Blackbridge, sets; Lizard Jones, sets; Andrea Fatona, production assistant; Lisa Badchelour, catering; Suzo Hickey, catering; Della McCreary, catering

Lorna Boschman, editor; Persimmon Blackbridge, assistant editor; Lizard Jones, sound

ROBERT FLACK

Love Mind (1992)
30 framed C-prints
56 x 66 cm each

FILMS AND VIDEOS

PEGGY AHWESH AND KEITH SANBORN

The Deadman (1989)
37 minutes, black and white, 16 mm, USA
A free and liberating (as well as liberated) adaptation of Georges Bataille's story "Le Mort."
Courtesy Drift Distribution

SADIE BENNING

Jollies (1990)
11 minutes, black and white, video, USA
Courtesy Women Make Movies

It Wasn't Love (1992)
20 minutes, black and white, video, USA
Sadie Benning is a young lesbian videomaker who has been creating videos since she was fifteen years old using a Fisher Price toy camera.
Courtesy Video Data Bank

LORNA BOSCHMAN

Scars (1987)
12 minutes, colour, video, Canada
Four women are interviewed about their experiences "slashing" and the resulting emotional release, guilt and societal disapproval.
Courtesy V Tape

COLIN CAMPBELL

Skin (1990)
18 minutes, colour, 16 mm, Canada
A sensuous and engaging film that focuses on women and AIDS.
Courtesy V Tape

STASIE FRIEDRICH

My Body is a Metaphor (1992)
7:30 minutes, colour, video, Canada
A provocative and highly visual piece that deals with the notion of the nonexistent human body as the result of social silencing, oppression and postcolonization.
Courtesy V Tape

LESLIE ASAKO GLADSJO

Stigmata (1992)
27 minutes, colour, video, USA
A documentary about women who are engaged in unusual forms of body modification such as tattooing, cutting, piercing and branding.
Courtesy Women Make Movies

PAULA LEVINE

Mirror Mirror (1987)
3 minutes, colour, video, USA
Shot in Venice, California, the tape is a short vignette about voyeurism, viewing and being viewed.
Courtesy Women Make Movies

MIDI ONODERA

Ten Cents a Dance (Parallax) (1986)
30 minutes, colour, 16 mm, Canada
Onodera's three-part reflection on contemporary sexuality and communication uses a split-screen device with a new twist.
Courtesy Canadian Filmmakers Distribution Centre

PRATIBHA PARMAR

Khush (1992)
24 minutes, colour, 16 mm, England
Khush means ecstatic pleasure in Urdu. For South Asian lesbians and gay men in Britain, North America and India (where homosexuality is still illegal), the term captures the blissful intricacies of being queer and of colour.
Courtesy Women Make Movies

GRETA SNIDER

Shred O'Sex (1992)
22 minutes, colour, 16 mm, USA
Greta Snider gave every member of her household a camera and one hundred feet of film. She asked each of them to record her or his own personal erotic movie.
Courtesy Drift Distribution

LISA STEELE

Birthday Suit—with Scars and Defects (1974)
12 minutes, black and white, video, Canada
On the occasion of her twenty-seventh birthday, the artist decided to make a tape that chronicles her passage through time.
Courtesy V Tape

KATE THOMAS

Francesca Woodman (1990)
6 minutes, colour, video, USA
A deeply erotic and moving tribute to the tormented American photographer Francesca Woodman.
Courtesy V Tape

Permissions Credits

Rick Bell, "Kissing and Telling in balmy Banff," reprinted with permission from *Alberta Report*.

Doug Main, "Letter to the editor," reprinted with permission from *Alberta Report*.

Link Byfield, "If Mr. Main wasn't responsible for subsidizing those Banff lesbians, then who was?" reprinted with permission from *Alberta Report*.

Jeff Harder, "Tax-funded gay sex play 'God-awful,'" reprinted with permission from the *Edmonton Sun*.

Nancy Tousley, "Kowalski triggers homophobia charges," reprinted with permission from the *Calgary Herald*.

Valerie Hauch, "'Morality' is not the point," reprinted with permission from the *Edmonton Sun*.

Rick Bell, "Culture grants painted black," reprinted with permission from the *Calgary Sun*.

"Controls on art funding proposed," reprinted with permission from the *Calgary Sun*.

Timothy le Riche, "Cuts will kill jobs, artists say," reprinted with permission from the *Edmonton Sun*.

Donald Robertson, "Where do you go to sign up," reprinted with permission from the *Calgary Herald* and Donald Robertson.

Alan Kellogg, "Tory musings have arts boosters worried," reprinted with permission from the *Edmonton Journal*.

Gillian Steward, "Alberta Conservatives running scared," reprinted with permission from Southam News.

H.J. Kirchhoff, "Arts groups unite in protest," reprinted with permission from the *Globe and Mail*.

Rick Bell, "Picture of controversy," reprinted with permission from the *Calgary Sun*.

"Political parade" front page format, flag, photograph and cutline, reprinted with permission from the *Banff Crag & Canyon*.

"Hundreds rally for the arts in Banff," reprinted with permission from the *Banff Crag & Canyon*.

Lizard Jones, "Kiss & Tell Spark Controversy in Alberta," reprinted with permission from *Mix* (formerly *Parallélogramme*) and Lizard Jones.

David McIntosh, "Sex-obsessed censors," reprinted with permission from *Xtra!* and David McIntosh.

Allyson Jeffs, "Risque art risks loss of funding," reprinted with permission from the *Calgary Herald*.

pages 2, 3, 4, 6-7, 10-11, 28, 29, 30, 33,
34, 38: Don Lee/Banff Centre
pages 5, 8, 31, 32, 36, 37: Cheryl
Bellows/Banff Centre
pages 14, 15, 21, 102, 106: courtesy
Vtape, Toronto
pages 16, 17, 22, 23: courtesy Women
Make Movies, New York
page 18: courtesy Video Data Bank,
Chicago
page 90: photo courtesy of Serge
Vaisman, Art 45, Montreal
page 96: courtesy Le Videographe inc.,
Montreal, photo Joanna Kotkowska
page 104, 105: courtesy The Power
Plant, Toronto

Photo Credits

Contributors

MAUREEN CONNOR is a New York-based artist who has been active as a visual artist for over two decades. Her work has been exhibited in Europe and across the United States, including the Whitney Museum of American Art and the Alternative Museum in New York City.

SU DITTA was the media arts curator at the National Gallery of Canada in Ottawa from 1987 until 1990. She then served as Head of the Media Arts division of the Canada Council for four years. Su is currently teaching and studying at Trent University in Peterborough, Ontario, in addition to working as an independent curator, critic and cultural policy analyst.

ROBERT FLACK lived in Toronto until his death in 1993. A graphic designer for many years, he also exhibited photographic artwork in Canada, the United States and Europe. A book titled *This Is True to Me* was published on his work posthumously by The Eternal Cosmic Love Machine Collective and Macdonald Stewart Art Centre.

SYLVIE GILBERT is a curator who has developed art exhibitions that explore critical issues in contemporary culture. She was curator at the Walter Phillips Gallery from 1989 to 1994 and currently works as an independent curator in Montreal.

THOMAS ALLEN HARRIS is a producer, director and writer of film and video who has worked extensively on broadcast projects and artworks that explore black culture, gay and lesbian sexual identity and social relationships. He has written for numerous books and publications, including *Madonnarama* and *Black Popular Culture,* and teaches at the University of California, San Diego.

KISS & TELL is a lesbian collective from Vancouver including Persimmon Blackbridge, Lizard Jones and Susan Stewart. Their first collaboration, *Drawing the Line,* toured across Canada and the United States and was also published as a postcard book. *True Inversions* is the second major project undertaken by the collective. Their most recent publication, *Her Tongue on My Theory: Images, Essays and Fantasies,* expands on the issues of *True Inversions.*

MYRNA KOSTASH is a Canadian non-fiction writer and award-winning author of several books, including *Bloodlines: A Journey into Eastern Europe, All of Baba's Children* and *The Doomed Bridegroom.* She has published numerous articles in cultural and literary magazines and was the Chair of the Writers' Union of Canada from 1993 to 1994. She lives in Edmonton, Alberta.

THOMAS WAUGH is a writer, critic and professor in the cinema department at Concordia University in Montreal. He has written extensively on gay culture and is the author of *Hard to Imagine: Gay Male Eroticism in Photography and Film from their Beginnings to Stonewall.*

Index